Tlingit
THEIR ART & CULTURE

DAVID HANCOCK

hancock
house

ISBN 0-88839-530-2
Copyright © 2003 David Hancock

Cataloguing in Publication Data
Hancock, David, 1938–
 Tlingit : their art & culture

 ISBN 0-88839-530-2

 1. Tlingit Indians—Social life and customs. 2. Tlingit
Indians—Material culture. 3. Indians of North America—Alaska—Social
life and customs. 4. Indians of North America—Alaska—Material
culture. I. Title.
E99.T6K33 2003 979.8'004972 C2003-910060-X

Editor: Mary Scott, Yvonne Lund
Production: Ingrid Luters

Photographs by David Hancock unless otherwise credited. Unfortunately many of the old photos are
uncredited as the photographer has long been forgotten.
Front cover photo: Tlingit ceremonial blanket and mask, painting by Susan Im Baumgarten.
Back cover photos: Bear mask carved in birch by Greg Horner (top, left); halibut hook (top, right);
longhouse with totem pole entrance, photo by David Hancock (bottom).

*We acknowledge the financial support of the Government of Canada through the
Book Publishing Industry Development Program (BPIDP) for our publishing activities.*

Published simultaneously in Canada and the United States by

HANCOCK HOUSE PUBLISHERS LTD.
19313 Zero Avenue, Surrey, B.C. V3S 9R9
(604) 538-1114 Fax (604) 538-2262

HANCOCK HOUSE PUBLISHERS
1431 Harrison Avenue, Blaine, WA 98230-5005
(604) 538-1114 Fax (604) 538-2262
Web Site: www.hancockhouse.com *email:* sales@hancockhouse.com

Contents

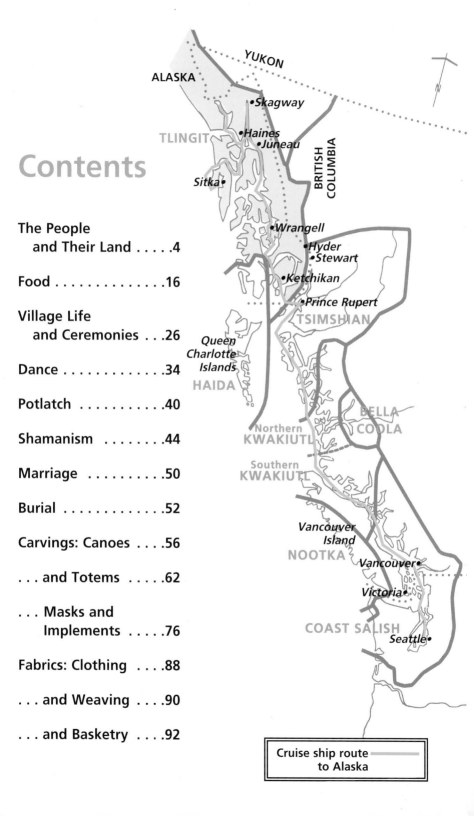

YUKON

ALASKA

•Skagway

TLINGIT

•Haines
•Juneau

Sitka•

BRITISH COLUMBIA

•Wrangell

•Hyder
•Stewart

•Ketchikan

•Prince Rupert

TSIMSHIAN

Queen
Charlotte
Islands

HAIDA

BELLA
COOLA

Northern
KWAKIUTL

Southern
KWAKIUTL

Vancouver
Island

NOOTKA

Vancouver•

Victoria•

COAST SALISH

Seattle•

Cruise ship route
to Alaska

The People and Their Land

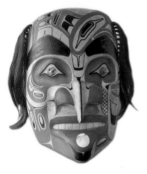

When you visit southeast Alaska you encounter the Tlingit Indians and their very rich lands, diversified culture and wondrous art forms. You can visit from cruise ships, from the Alaska Ferry system, from private boats, from the air or by following the highway systems through Hyder, Skagway or Haines.

The richness of the culture flows from the incredible diversity and abundance of the surrounding seas: its fish, whales and sea life, the prolific clam beaches, and incredible wealth from the spawning fish that feed the bears, eagles and nutrify the dense coniferous forests. The ease with which the natives could extract a good living provided much extra time to devote to developing an extraordinarily rich culture and a prolific art, as well as the warring and slave trading that set the northwest coast peoples apart from other more food-deprived North American native peoples.

This book will give you a glimpse into the richness of their land and art and afford you some understanding how the Tlingit evolved as part of this productive land.

Visitors to Alaska call the Tlingit, "natives" or "Indians." The name "Tlingit" which the natives call themselves means the "people." Tlingit has been written many ways—"G-tinkit," "T-linkit," "Thinket." It is pronounced "Clink-it." It is estimated that there are about 15,000 Alaskan natives today, and over half of them are Tlingits. The balance are Eskimos (Inuit), Aleuts and Athapaskan Indians.

The Tlingit form a distinct ethnic and linguistic group of the Koluschan stock. Koluschan is from the Russian "kalyushka," meaning piece of wood (worn in the lower lip). They occupy a compact geographical area along the Pacific coast from about Mount St. Elias to the Nass River, including Sitka and the other adjacent islands of the Alexander Archipelago. The chief tribes are the

Tlingit ceremonial blanket and mask. Painting: Susan Im Baumgarten

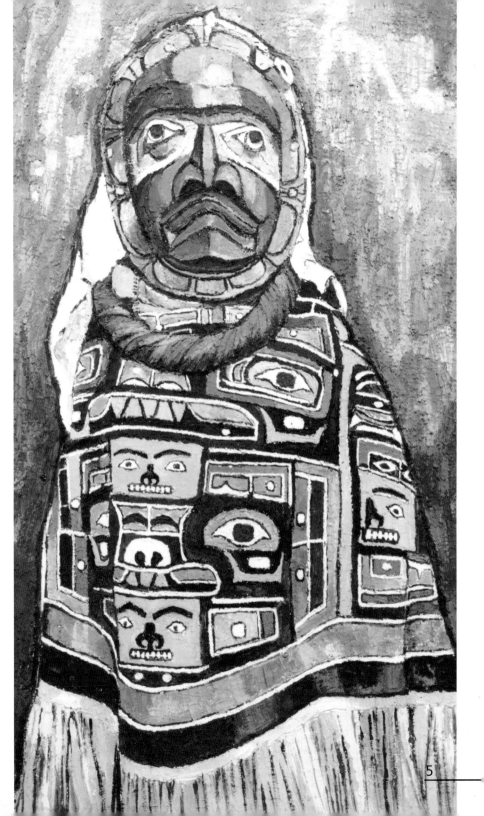

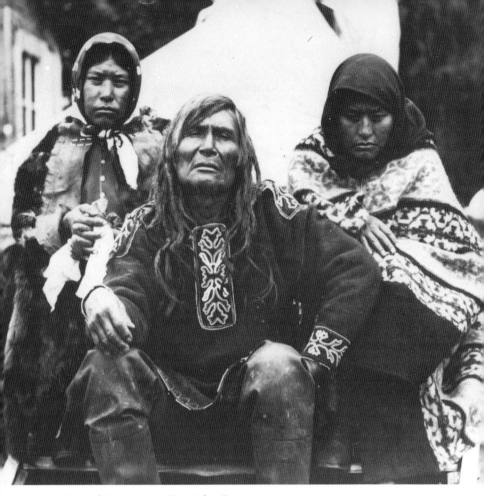

Turn of the century Tlingit family. Photo: Royal B.C. Museum

Yakutat, Chilkat, Sitka, and Stikine. More recently there is also an inland Tlingit subgroup that occupies the area from Whitehorse, Yukon, south through the area of Atlin, British Columbia, down to the Taku and Stikine Rivers. They were originally a seafaring people and today have adapted to work in the salmon, forestry and tourist industries. Prior to the deterioration suffered from contact with the white race, they were the foremost traders of the northwest—often trading with the other interior natives of North America.

The Tlingit language seems to be completely isolated, showing nothing beyond the faintest verbal resemblance to the Aleut and Eskimo and the more southern Haida. A recent observation has been

that it bears some affinity to Mexican tongues. It has a plural in "k," and an instrumental form in "tich" or "tsh," the combination of which produces a heaping up of final consonants, which none but the natives can produce.

Just where these people originated is a matter of speculation. Like the southern Indians, they have high cheek bones, straight black hair, black eyes and dark skins. Their eyes do not slant, however, as do the eyes of the Eskimo and Aleut, but they do possess the Mongolian spot at the base of their spine. The purer Tlingit type is short, with a stocky body and broad face.

Through legend the Tlingit claim to have been on the first Mongolian migratory wave across the Bering Strait and found openings through the glaciers which eventually led them to the Chilkat River. For the most part, they settled in the island areas of southeastern Alaska, with only a few exceptional settlements in the Yakatat and Chilkat areas on the mainland. Anthropologists and explorers back in the 1880s estimated the entire population of the Tlingit to be 10,000. When Western contact was made, European diseases swiftly reduced the population to around 4,000. According to the old folks, smallpox was the most devastating contributor to this loss.

Living in close contact in large communal houses it is easy to see how such a disease could spread when the people did not know what was causing it, or what the treatment should be. Tuberculosis, syphilis and other diseases introduced by white traders had devastating results. Some have since suggested the Indians got even or came out better as the eastern Indians introduced tobacco to the white people!

The first major western contact was through the Russian settlement at Sitka, on Baranof Island. The Tlingit were hostile to the Russian

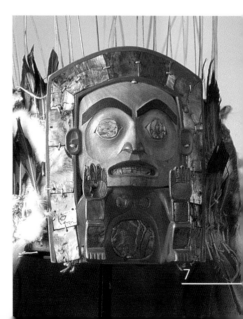

Chief's mask frontlet.

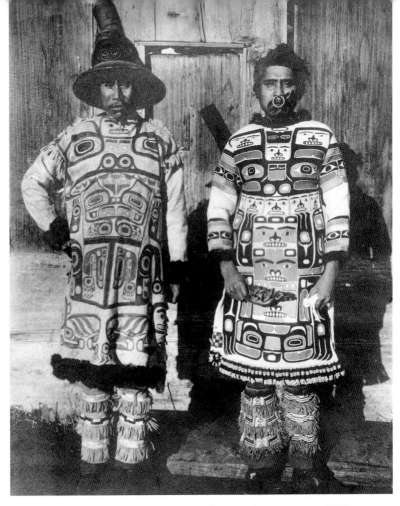

Two Chilkat chiefs of Conuhtade band in dancing costumes 1895.
Photo: Canadian Museum of Civilization

settlement for a number of years, but gradually the Indian women were seduced by the Russian men of the expanding colonies, and thus interbreeding began. In fact, in Alaska today it is hard to find a "pure" Tlingit. Most of the people have some Russian, English, Irish, Norwegian or other blood in their veins.

In 1867, Russia sold Alaska to the United States for $7,200,000 through the efforts of William H. Seward, Abraham Lincoln's Secretary of State. The odd $200,000 was to give clear title to the land, but Indian land rights were unsure until the "Claims Settlement Bill" was passed in 1971, ahead of the pipeline bill. The

Opposite: *Chilkat longhouse at Haines.*

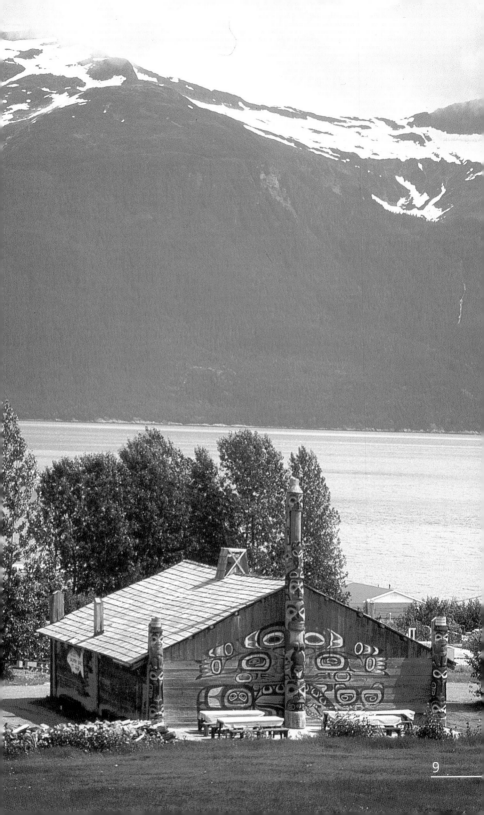

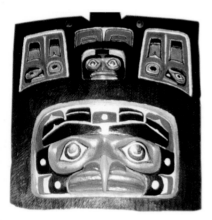

Left:
Part of old Tlingit inside house post,
Sitka Museum.

Opposite: *Fine Tlingit Chief blanket*
passed down by marriage to Kwakiutl
Chief Don Assu and worn at his potlatch
in Campbell River, B.C. in 2002.

bill provided that in ten years $1 billion was to be distributed to natives, some of it to individuals, but mostly to regional and village corporations in which natives would be stockholders. Regional and village corporations selected millions of acres of land that was held by the federal government. They conveyed some of this to individuals, to be used for homes, and set aside large tracts in the north for reindeer herds.

The climate of the Alexander Archipelago is mild the year round owing to the Japanese current. Because of the heavy rainfall, ranging from ninety to two hundred and twelve inches a year, the country is overcast and wet much of the time. The dry season occurs during the months of June, July and August, and even then it rains while the sun shines. Typical of western North America, the summer months are punctuated by sea fog that moves in during the night and often burns off by midday. In the early days is was said that a week of fair weather would frighten some of the natives, who retreated to the spruce forests in order to keep from getting sunstroke. The weather of this region has been steadily warming since the days of the early explorers. The Glacier Bay glaciers witnessed by Captain Cook in 1778 have melted back over 60 miles.

Out of two recent cruise ship tours through the Tlingit country we only encountered one wet day — and we still took some fine color-rich photos of the Saxman poles of Ketchikan in the drizzle.

There are coniferous trees everywhere, chiefly spruce, hemlock, cedar and Douglas fir. The deciduous cottonwood and alder trees are also common along the waterways and clearcuts. The country is

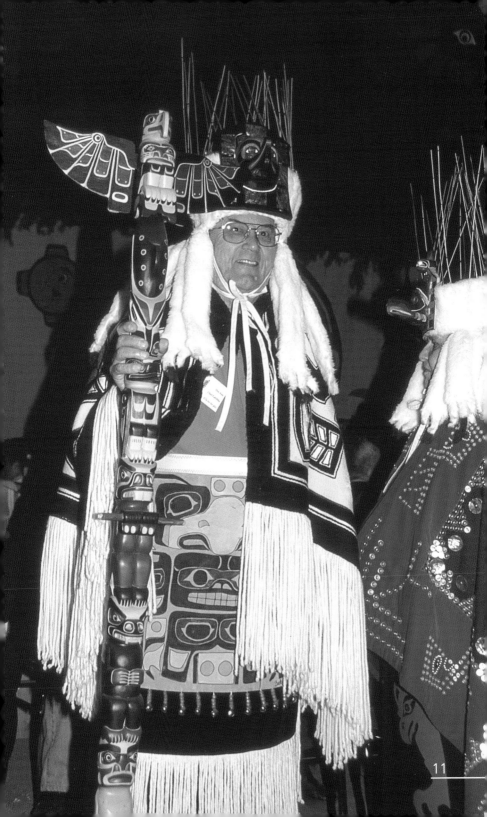

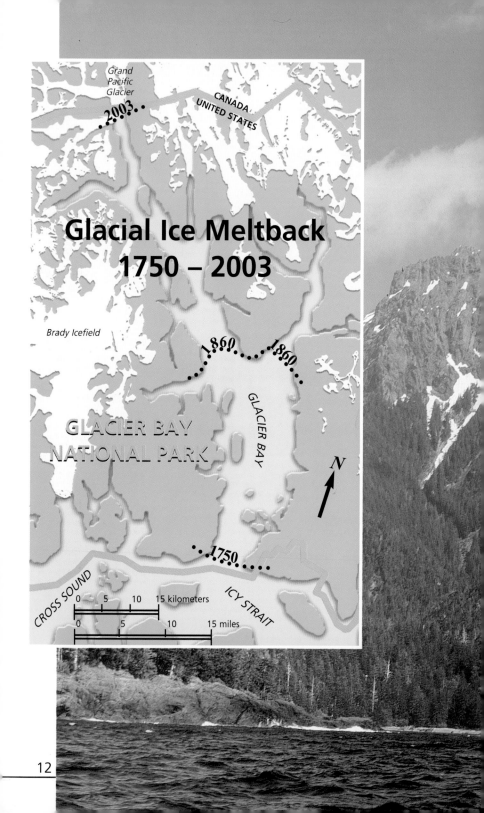

Grand
Pacific
Glacier

CANADA
UNITED STATES

2003

Glacial Ice Meltback
1750 – 2003

Brady Icefield

1860 1860

GLACIER BAY
NATIONAL PARK

GLACIER BAY

N

1750

CROSS SOUND

ICY STRAIT

0 5 10 15 kilometers

0 5 10 15 miles

Typical Alaska inside passage view .
Insets: *Juvenile* (left) *and adult* (right) *bald eagle.*

rich in mineral deposits which are not easily located because of the thick vegetation. There is a great deal of free copper in the vicinity of Klawock. The Tlingit call this copper "tinna," and were proficient in making ornaments from it such as earrings, finger rings, bracelets, necklaces, and wall hangings—in addition to the most prized northwest crest, the "Copper".

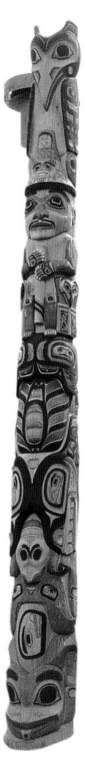

Above: *Gathering at Wrangell.*
Photo: Canadian Museum of Civilization

Right: *Raven pole at Haines.*

Left: *Tlingit copper.*

Food

Tufted puffin.

Before white people entered their domain the Tlingit were exclusively hunters and gatherers. The staple food was fish, especially salmon caught by the men. Salmon could be caught at all seasons but it was during their upstream spawning migration that the biggest volumes were readily available. The summer salmon spawning runs were available from almost every river—from the tiniest creeks to major rivers with many tributaries. The fish were dipped with nets, speared or funneled into traps by the men.

Women smoked and dried the salmon during the summer in quantities that would last them until the next spawning season. Since the salmon came back to the same streams in which they were hatched, in cycles of every two, three or four years, the Indians were always sure of food. The salmon diet was supplemented by halibut, herring, cod, red snapper, seal, an occasional whale, crabs, abalones, and the staple, clams. In fact, they ate almost anything that the seas offered. Sea urchin eggs were considered a delicacy. Seaweed was dried and eaten as we would peanuts. The seaweed was rich in bromine and iodine, and therefore there were no goiters found in the Tlingit. Venison, bear, ptarmigan, goose, duck and other game were hunted in their season of availability. The Tlingit were particularly fond of an oil from the candlefish or oolichan obtained by barter from the mainland Tsimshian and the Haidas from Prince of Wales Island to the south.

The greatest food reserve of the coastal people came from the great beds of mussels, abalone, cockles and clams that became available just for the picking at each low tide. This incredible reserve was not just good succulent food but could be harvested year round in good or bad weather. It is impossible to starve to death or even go wanting while living in the coastal northwest with access to the abundant life of the seashore. Today the ancient coastal villages are evident by the huge shell middens that underlay the old sites. From the air, the old abandoned village sites are clearly apparent from the

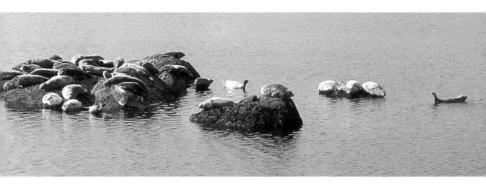

Harbor seals sunning on rocks —a good source of skins, meat, sinew and bone awls—and bladders for floating whales.

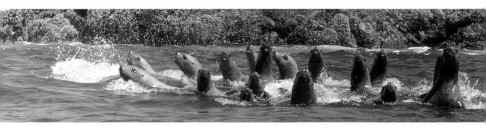

Stellar's sealions—in water and below, 2000 pounds of belligerence.

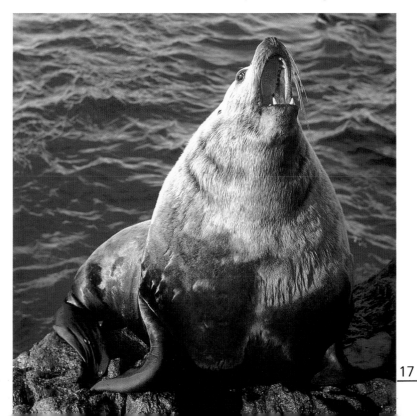

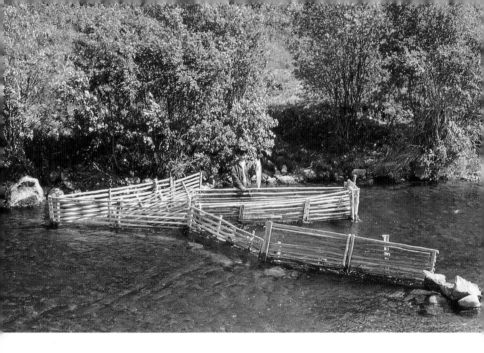

Salmon trap and split-open, drying sockeye at Klukshu village on Haines' cut-off road.

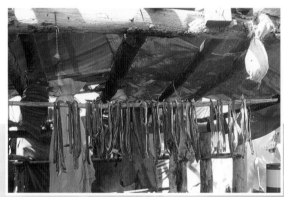

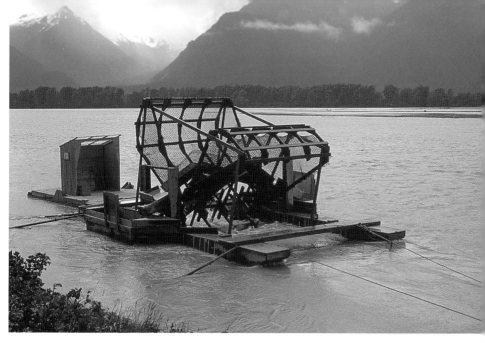

Modern Indian salmon trap on the Chilkat River.

Smoke houses on beach, late 1800s. Photo: Canadian Museum of Civilization

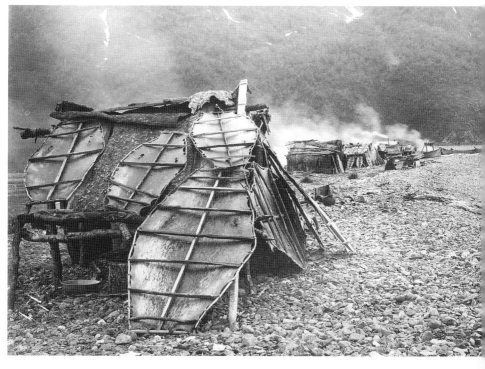

lighter colored encroaching vegetation growing on the high calcium rich soils—the garbage dumps of seashells sometimes twenty feet deep.

Halibut hook.

Another important season for the Tlingit was herring-spawning time in March. Spruce branches were put into the water along the shore. The eggs of the herring then adhered to the spruce needles which were pulled up every day or two bearing thousands of eggs. The Indians enjoyed eating these eggs raw or with oolichan oil. The oolichan or candle-fish oil is referred to as Tlingit honey. Today many of the men, along with white fishermen, still fish for herring using fine mesh gill nets but most herring are caught in large seine nets by the hundred ton and sold to the Japanese. This pillage of the herring is probably the most

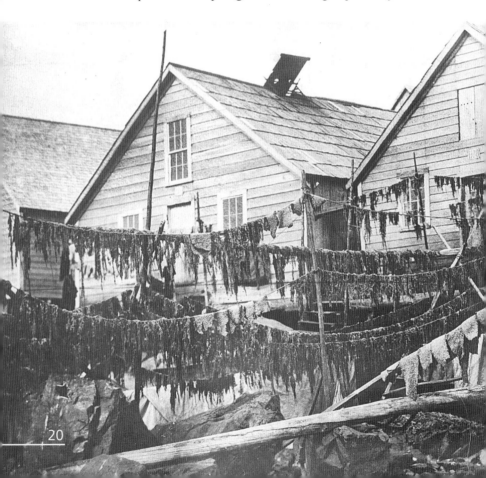

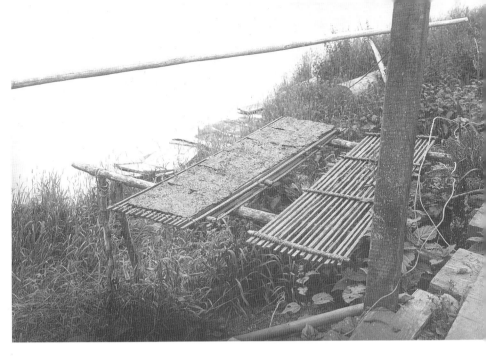

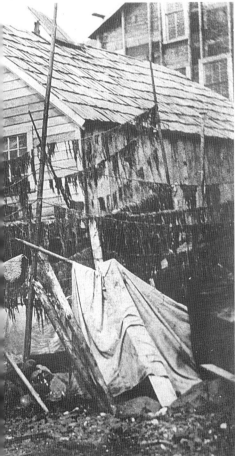

Above: *Berries drying for winter.*
Photo: Canadian Museum of Civilization

Left: *Herring eggs drying in front of Sitka village 1889. These were gathered in March and April from spruce branches hung in the water and on which the herring spawned. These eggs were considered a delicacy and eaten raw, dried or mixed with oolichan oil.*
Photo: Canadian Museum of Civilization

Tlingit Tools

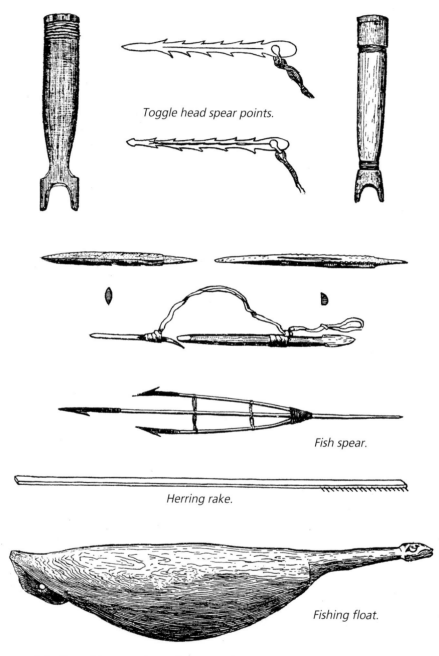

Toggle head spear points.

Fish spear.

Herring rake.

Fishing float.

Selection of bone and wood spears, a herring rake and seal bladder float.

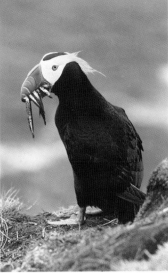

Black and grizzly bears were frequent competitors on the salmon spawning rivers. The tufted puffin along with murres and gulls offered a spring feast when these birds gathered on the offshore islands to breed.

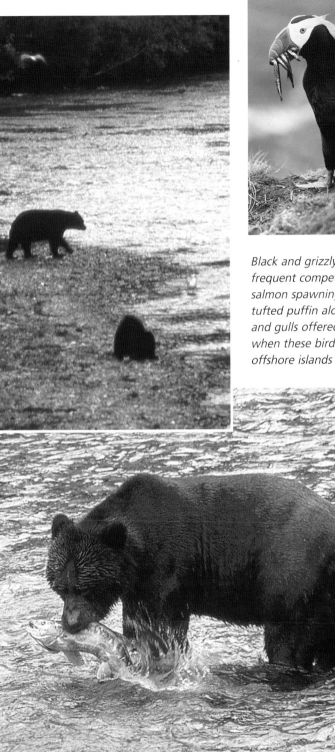

23

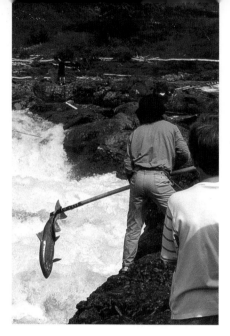

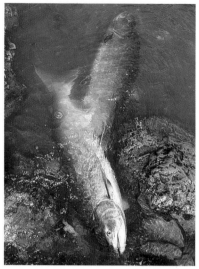

All five species of salmon were harvested—some by gaffing.

destructive ecological process of the coast as it negatively impacts the salmon, cod and halibut fisheries, as well as decimating sea lion stocks and the herring themselves.

Every Tlingit boy who grew up in sight of the sea was taught seamanship and navigation and knew the intricacies of how to fish and handle a boat. The simple one-man operated gillnet remains incredibly effective at catching mid-water fish: herring or salmon. As one can guess from its name, the gill net snares the fish by entangling their gill covers in the net mesh. The gill net is suspended downward from a rope held up with cork floats. With the aid of sinkers, it stands erect in the water. The size of the mesh depends on the size of the fish to be caught, and the net is let out from a small boat, across the path of the fish run, the free end generally fastened to a buoy in the water. It is

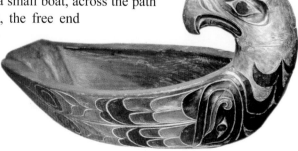

Food served on festive occasions would be offered in finely decorated eagle or sea otter bowls and generally stored in bent cedar wood boxes.

This is a cross section of a typical midden revealing the many years or centuries of discarded clam and mussel shells and other garbage.

better to gill net fish at night or in muddy rivers. In the daytime the fish can see the net and avoid being caught.

The first salmon canneries in Alaska were located at Klawock: these were the Peratrovich Cannery and the Demmert Cannery. Both were owned and operated by Tlingits. Again, while the men fished, the women would get jobs for an hourly wage in the salmon canneries. Today, using high speed boats, much of the fish is whisked off to the fresh food markets of the southern states or processed in local modern canneries.

Huckleberries, salmonberries, salal berries and thimbleberries were prolific in this area wherever sunlight could reach the ground along river estuaries or clearcuts and were used as food in season. The Indian children were very fond of the shoots of the salmonberry and wild parsnip. In the spring, usually about the middle of May, they sucked on these sweet shoots as white children suck candy.

Some hunting was done. Mountain goats were treasured for their fine wool used to weave the chiefs' blankets. Some deer, bear, ptarmigan and grouse were hunted. Seabird eggs and the birds themselves were locally utilized in season. And of course the seals, sealions and whales were hunted by some tribes. These hunts, which involved great risk to the hunters, are the stories of many legends expounding bravery and often supernatural skills.

Village Life and Ceremonies

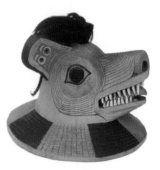

Village life had two seasons for most coast villages. The permanent winter villages with longhouses were located on the outer islands and coastal areas and featured leisure time for developing arts and crafts, for feasting and dancing, and for war and capturing slaves. The summer villages were located at trapping sites on a salmon spawning river and usually offered adjacent clearcuts for gathering berries and drying the salmon.

One of the great strengths of the Tlingit was that everyone in the society had some part in the community and, therefore, could enjoy and understand it. Each person had a position which gave a specific relationship to those above and those below. Even the slaves, captured in war, taken in trade or born into slavery, "belonged" and had responsibilities and privileges that were shared as a part of everyday living. A woman could even extricate herself from slavery by marrying a free man; a man could free himself by valor or some act of unusual courage. Social rules, moral codes and taboos were strictly adhered to and any departure from these standards usually meant severe ostracism or death. The ethic underlying these moral codes was "an eye for an eye and a tooth for a tooth."

In the olden days, it was the custom of the natives to gather together in the permanent coastal villages during the winter months. They lived in community houses made of split cedar logs which were built into the ground for warmth as well as for greater protection from their enemies. Several dozen to a hundred people would occupy one community house, a structure with one large room. The floor of the community house was terraced to maintain the different social levels even in close proximity. Many of the houses were 40 to 60 feet wide and 100 to 200 feet long — the longest being 600 feet. The insides were adorned with house poles and divided into family living areas by decorated screens. The central fire pit heated

Opposite: Inside house post, Juneau Museum.

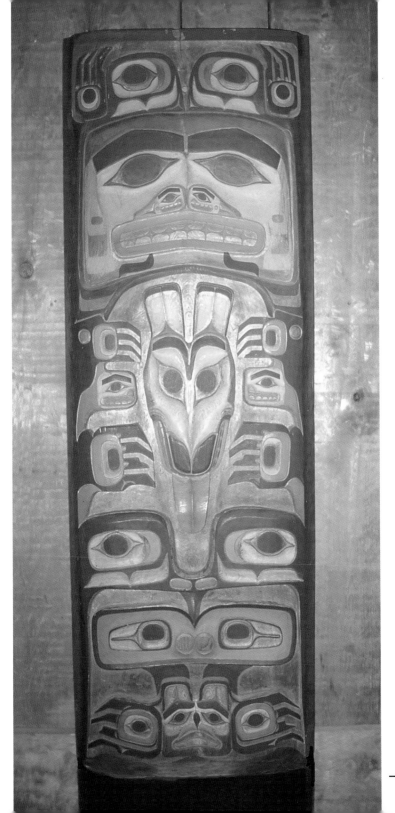

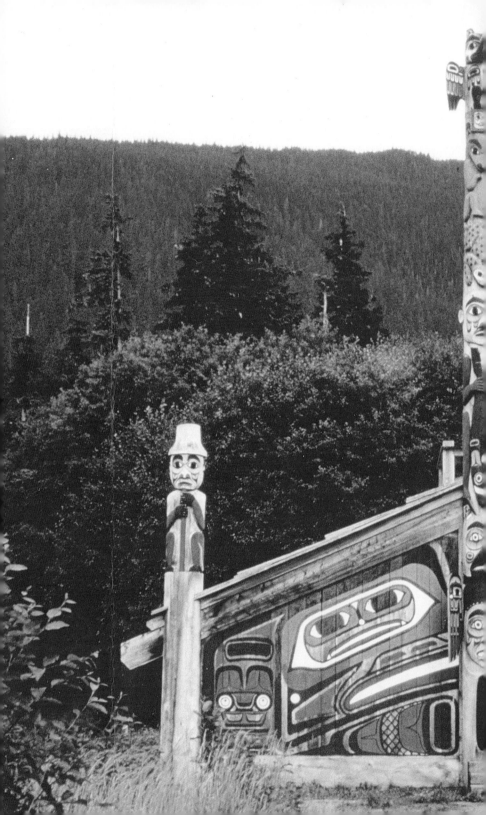

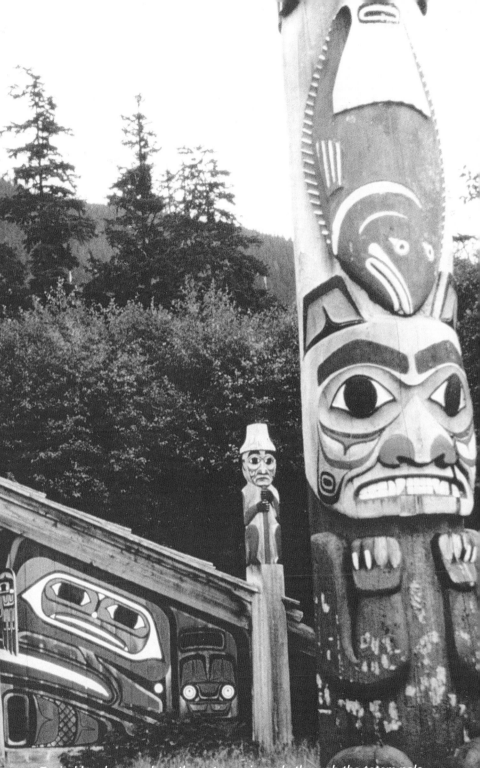

Typical longhouse where the entrance is made through the totem pole.

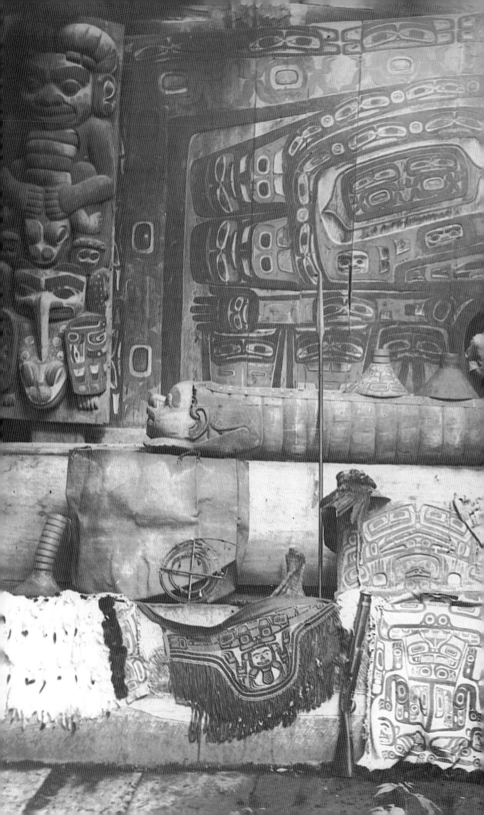

Inside Tlingit longhouse—showing two of the inside house posts supporting the roof, the different tiered levels on which different castes lived and showing a variety of fine ceremonial robes, hats and a mask. The long log behind the person on the top level was a log drum.

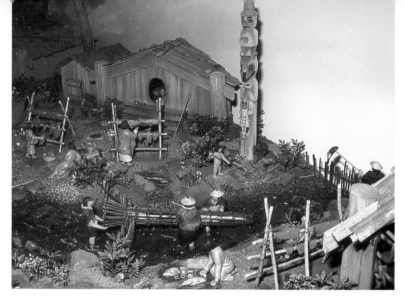

Model of Tlingit village, Anchorage Museum.

and lighted the area as well as providing the central cooking area. It was around this same central fire pit that the story telling and potlatching occurred.

During the short winter days, the men might hunt or fish, make repairs on their houses or attend to repairing harpoon shafts or rechipping sharp edges on the shell or stone knives and harpoon heads. Others would be commissioned to carve poles, masks or canoes for trade, war or potlatching. The women would gather firewood, prepare meals and soak roots and rushes to soften for making new baskets. Life was leisurely until the preparation for a feast or potlatch began or plans for warring raids were undertaken.

Floor plan of the Whale House. Lt. George Emmons, The Whale House of the Chilkat, 1916. Anthropological Papers of the American Museum of Natural History. V.19, pt. p. 21, fig. 5.

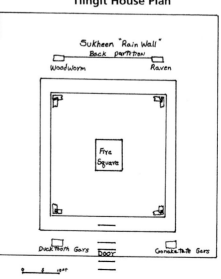

Tlingit House Plan

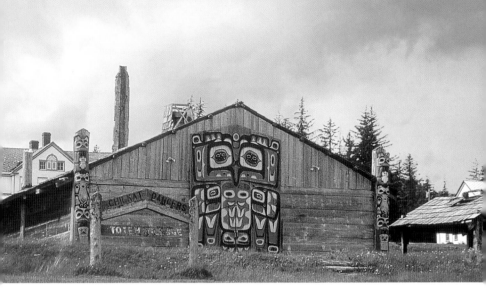

Haines longhouse—home of the Chilkat dancers.

Chief Shakes rebuilt tribal longhouse and poles. Photo: Marilyn Williams

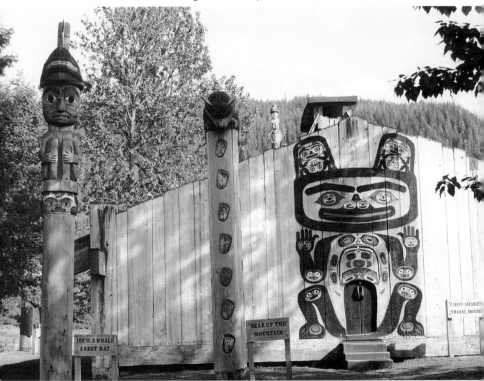

Dance

Puffin mask.

With no written record available, the learned knowledge of a people had to be passed on verbally, aided by dance and art. Therefore the history, legends, mythology and taboos were related to the young and the mindful through story telling and elaborate costumed plays involving much singing, dancing and feasting. These activities might be simple, improvised dances around the evening fire or an all-out potlatch lasting from one to several days. In any event, the Tlingit enjoyed dancing, and the participants would display the family crests of ravens, bears, killer whales, or other real or mythological animals of the sea or forest. The motions of the animals were imitated in dance, and a certain combination of motions told a particular story which was understood by the viewer. While they danced, the tribal poets and bards recited songs and stories. The only instrumental accompaniment was the drum. In such fashion the dancer told a personal story of how he/she got a personal crest, or perhaps made peace with enemies or resolved a conflict with a fellow-tribes person. This later custom is analogous to the southern Indian's custom of smoking the pipe of peace. In one ceremonial dance the dancer approached the person he had offended and went through certain motions which when interpreted meant:

> *I am sorry that I displeased you.*
> *I shall take our trouble to the middle of the sea*
> *And there sink it beneath the waves,*
> *That it might be buried forever.*

Today many of the families and tribal groups again use dance to convey the family history, traditions and values. It is interesting to note that several Tlingit Villages voted to abolish the traditional potlatch when the competitive nature of the gift giving got out of hand in the late 1800s. Even today it is more likely to find a dance or feast being held to commemorate some event than find a full potlatch.

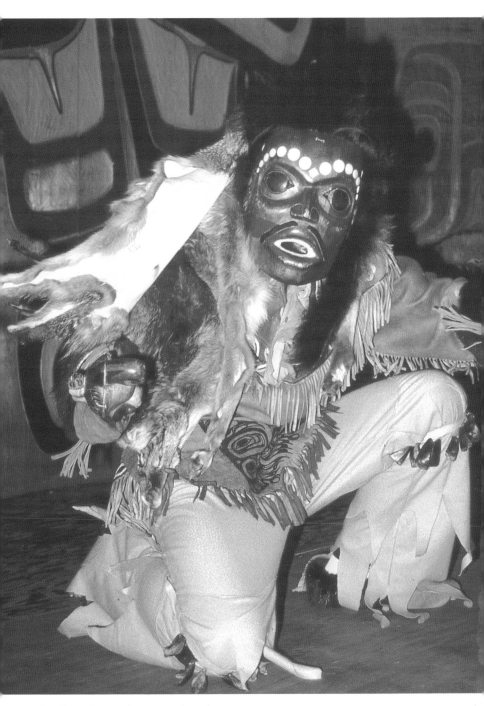

Tresham Gregg dance, mask and costume—a contemporary storytelling troupe in Haines.

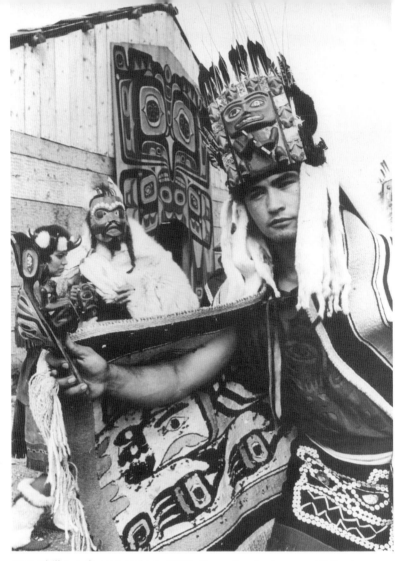

Port Chilkoot dancer, Haines, 1962. Photo: Canadian Museum of Civilization

The Chilkat Dancers, organized in 1957 at Port Chilkoot, near Haines, have attained world recognition and have done much to foster further interest in traditional native culture. The last reorganization of dancers, coordinated by Tresham Gregg, are still, in 2003, performing dance and storytelling in the Haines Longhouse in the town square.

The dancers wear masks representative of both natural and supernatural beasts: the Bear, Raven, Cannibal Spirit, or supernat-

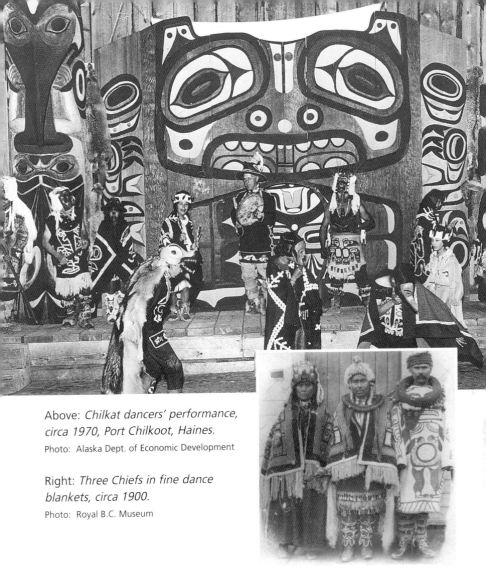

Above: *Chilkat dancers' performance, circa 1970, Port Chilkoot, Haines.*
Photo: Alaska Dept. of Economic Development

Right: *Three Chiefs in fine dance blankets, circa 1900.*
Photo: Royal B.C. Museum

ural Eagle among many. Some of the masks use several moveable parts; others are called transformation masks in which the dancer transforms himself from one natural beast to perhaps another supernatural beast by the process of the first mask opening up to reveal a second mask underneath.. Usually this invokes the power of Raven, the trickster. The Shaman Dance featured the shaman making a person well or entering a young initiate into the Secret Society.

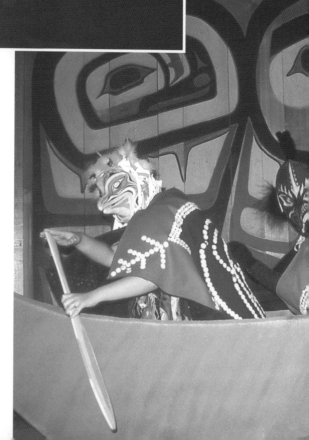

Mask, costumes and
dance by Tresham Gregg
contemporary dance and
storytelling troupe of
Haines.

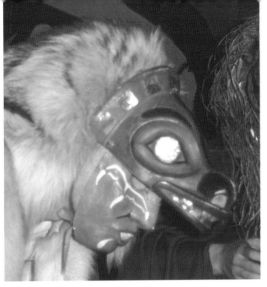

Wolf mask.

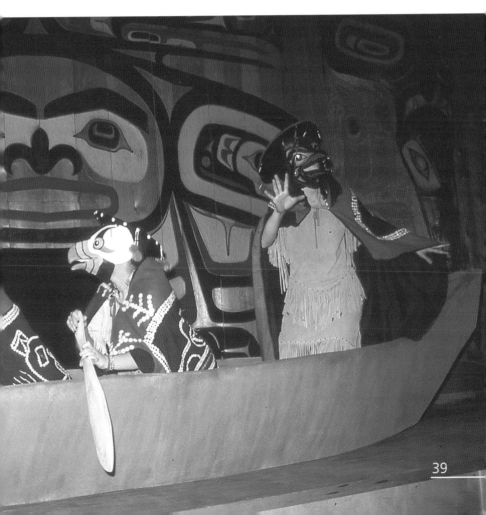

Potlatch

It was during the leisure of the winter months that most of the Tlingits' socializing and festive ceremonies were held. The potlatch was the most important of these. It was a feast given by a tribal chieftain, sub-chief or person of wealth to commemorate a marriage, a death, to celebrate a victory, to repay a debt, to acquire a name or spirit guardian, or to re-establish friendly relations between two rivals. A good hunter, carver or shaman could also collect wealth through his efforts and craftsmanship. Relatives of lower social status and slaves were obliged to contribute to the wealth of their chiefs and superiors, even if this meant incurring debt. In return, they gained greater social status by association with the chief who was giving the potlatch.

The potlatch was marked by feasting, dancing and particularly storytelling, and highlighted by the giving away of property such as blankets, canoes, slaves, fishing rights, and food. The potlatch giver would take great effort to tell the stories of his achievements, his victories or purposes for giving or taking a particular name or crest. Very often the feasting and festivities might last three or four days or more. A totem pole could be erected in commemoration of such an event. The chief's conical hat would earn another ring for each

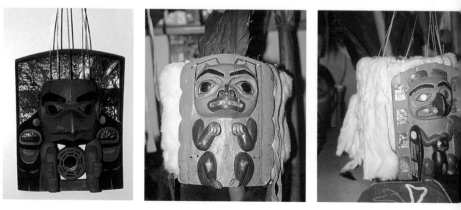

Chief's mask frontlets.

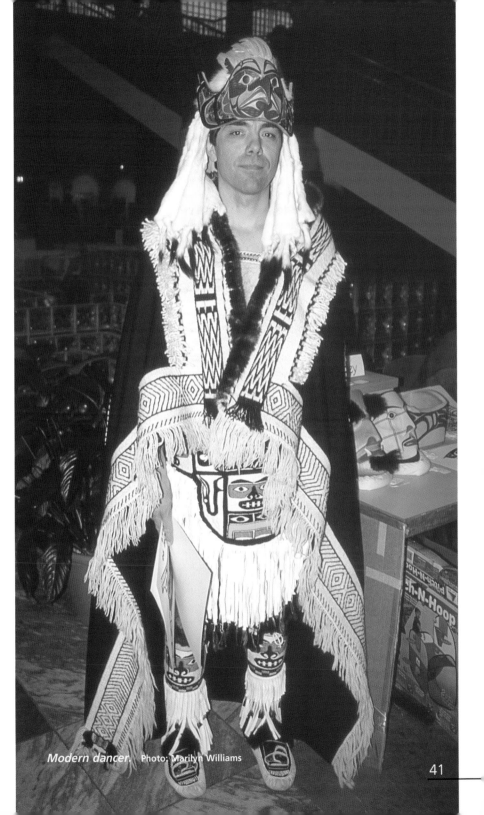

Modern dancer. Photo: Marilyn Williams

41

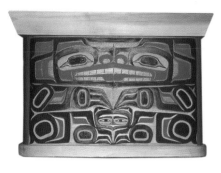

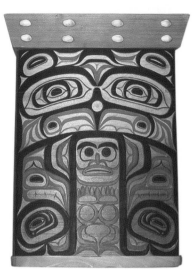

Two decorated contemporary storage bent boxes, Skagway Museum.

potlatch he gave. It often took the chief many years to gather up enough wealth to give away and this usually rendered the chief temporarily poor, but it heightened his social prestige and renown. To be well thought of in the eyes of fellow tribesmen was dearer to the heart of northwest coast Indians than untold riches. However, altruism alone wasn't the motive, for each gift given demanded the return of some future gift of greater value than the one received or humiliation and loss of face occurred. To this day the greatest harm that can befall a Tlingit Indian is to have "shame brought upon his face."

The gifts presented could range from valuable canoes, dancing blankets, tools and much food. But even more important in gaining prestige by giving a gift was the act of destroying or partially defacing a valuable item. For example, giving a very valuable copper was indeed an honorable event — but destroying that same copper or breaking it up into pieces and distributing those pieces to the 'put down receivers,' showed the chief to be even more wealthy. A fine woven hat that might take a woman a year to produce was a great gift—but to make a public display of putting that hat into the fire or cutting it with a knife aroused awe and indebtedness among the viewers and gave greater prestige to the chief.

Most commonly prestige was acquired through birth right. The chief inherited chieftainship and with it rights to certain masks, names and hunting territories and consequently the right to demand

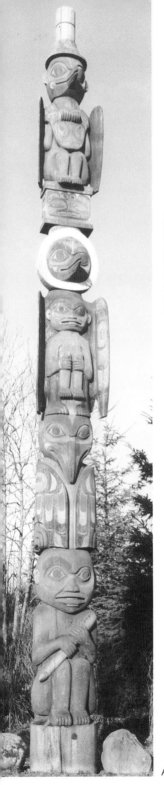

A

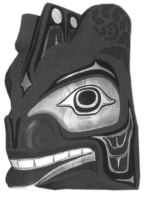

B

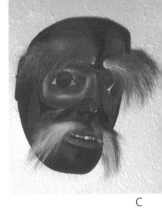

C

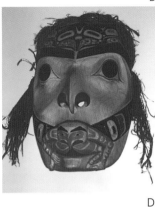

D

A: *Wrangell raven pole.*
Photo: Marilyn Williams

B: *Sea Wolf by Tresham Gregg.*

C: *Spirit Mask by Stan Maisden.*

D: *Hawk Man with Eagle Dancer emerging*

followers donate gifts to be given away at potlatches. It was this obligation of the tribal members to their chief that brought the potlatch into disrepute. Terribly greedy power driven chiefs would demand these obligatory payments from the tribal members, often keeping them in poverty so the chief could be the great benevolent giver of gifts. It is not surprising that many of the village elders voted to do away with potlatches in 1904. Today potlatching is still uncommon among the Tlingit who favor festive dancing and feasting to convey their history, legends and accomplishments.

Shamanism

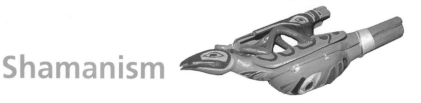

Shaman's rattle.

The individual's need for explanations of worldly events led to the foundation of a belief system based on spiritualism and reinforced by strict tribal laws about behavior. In this system all creatures—plants, animals and humans—had an inner spirit; and all creatures—natural and supernatural—were understood to have a social life like humans. This meant that you could enter the spirit world of salmon and find the Salmon Chief in his longhouse under the sea, or enter the spirit world of eagles and find the Eagle Chief in his longhouse in the sky organizing his tribal members. This spiritual dimension was mediated by the shaman. People, with the right guidance, could move back and forth between the human and spirit world.

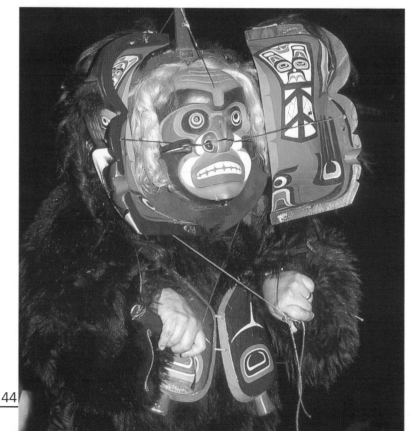

Full costume of D'sonoqua, the feared wild woman of the woods.

Opposite: One of two transformation faces of D'sonoqua by Tsangani.

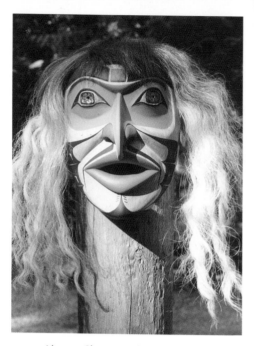

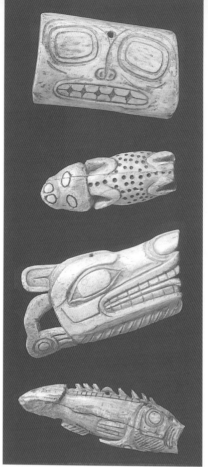

Above: *Shaman's helper.*
Photo: Marilyn Williams

Right: *Shaman bone carvings.*

Shamanism is a practice whereby the shaman utilizes illusion, natural medicines and incantations combined with the altered state of the patient to access the spiritual or supernatural realm to diagnose, treat and prescribe for the benefit of the tribe, the village, individuals or self. The ways a shaman attains his altered state is by dancing, drumming, rattling, incantations and creating ceremonies to activate plant, animal and mythical spirits. The individual might attain his altered state by food or water deprivation, by withstanding extreme body heat or cold, or by suffering extensive body rubbing by prickly plants. Often four days of these deprivations were endured before the patient or person seeking a vision was additionally subjected to excitement, flickering fire lights and sounds.

The shaman, after very rigorous training to separate out his/her

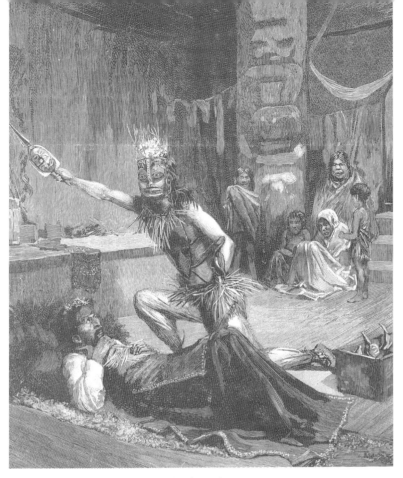

Shaman invoking the spirits to heal a sick man.

own personal needs, develops several specific spirit avenues and is able to mobilize the patient's own spirits and strengths for natural healing. The shaman or medicine persons were of high status. Healing methods involved both herbal remedies and magical rites. Success depended largely upon the cooperation and personal faith of the patient. Thus, wearing special necklaces, robes and masks, and shaking rattles, chanting and dancing around the patient, the shaman sought to access guardian spirits and to exorcize or placate the disturbed or evil entities of the spirit world believed to be the cause of most ailments. If successful, the shaman would receive a fee of otter skins or baskets of clams—the payment being related to the difficulty of the cure. If unsuccessful usually no fee would be collected — unlike our doctors and pharmaceutical companies today.

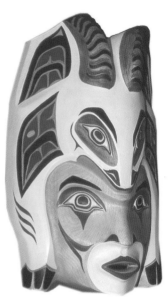

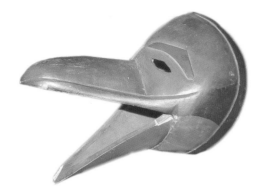

Above: *Shaman raven mask, Haines Museum.*

Left: *Mountain goat shaman mask by Tresham Gregg, Haines.*

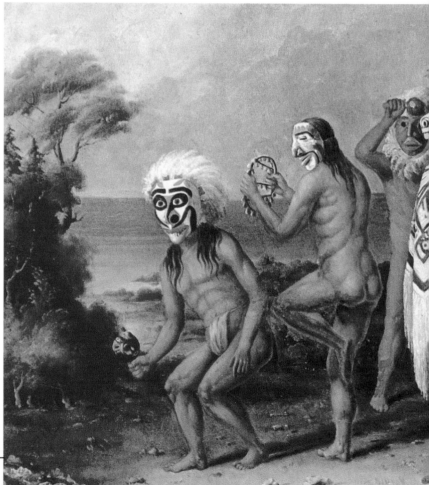

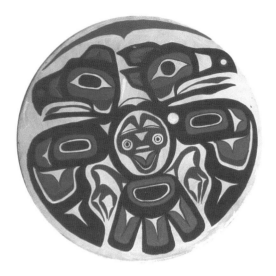

Right: *Shaman's Raven-Eagle drum, Saxman Village Store.*

Below: *Composite of Shaman dancers wearing many spirit masks. Note that in the early days the natives wore little clothing except in cold weather.*

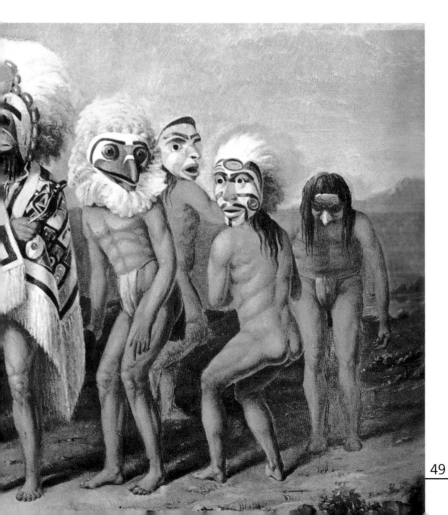

Marriage

The Tlingit are divided into two great branches: the Eagles and the Ravens. This division was observed by all tribes. It was a device to keep the people from inbreeding. A Raven must always marry an Eagle, never a Raven. The child of a marriage took the lineage of its mother. In this matriarchal lineage, if the mother was a Raven, the child became a Raven. In the event of the death of a husband, the husband's nearest male kin married the widow. This resulted in unions between very old men and very young women, and very old women and very young men. In the late 1800s, with the advent of a U.S. Commissioner, the Indians were required to undergo at least a government marriage ceremony. The church service was optional. When one native was asked why he had only gone to the Commissioner and not to the minister, he replied: "Minister marry me for good. Commissioner charge seven dollars and marry me today. Tomorrow I give him another seven dollars and I no longer married."

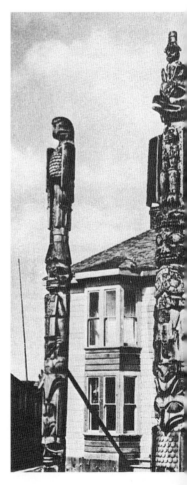

Above: *Raven blanket.*

Right: *House belonging to Chief Kad-a-shan, in the Tlingit town of Stikines.*
Photo: Canadian Museum of Civilization

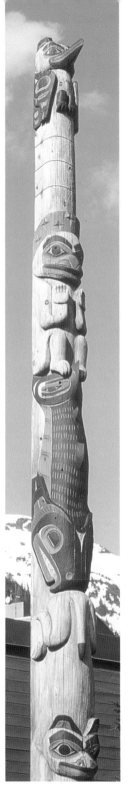

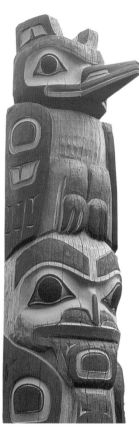

Left: *Raven pole overlooks Juneau.*

Above and right: *Raven and Eagle crest figures representing the two Tlingit lineages.*

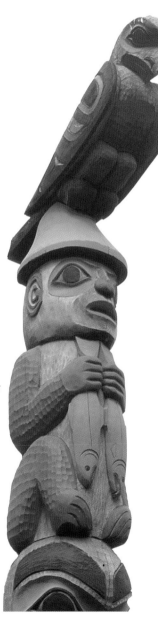

Burial

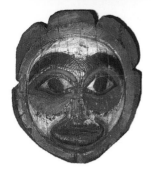

The Tlingit burned their dead relatives along with their possessions such as valuable blankets, carved halibut hooks, fish clubs and spears. For those who could afford it, the ashes of the cremated were placed in a niche carved into the back and top of a special totem pole. A downside existed for the deceased persons' slaves as they could be sacrificed at the burning. The Europeans introduced burial, which is the custom today. However, The Dead Feast is still observed. After the deceased has been mourned by professional mourners, a feast is given by the immediate relations of the depart-

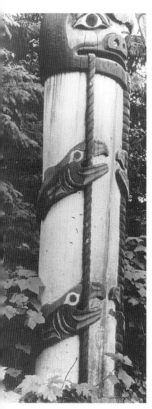

ed one. At such a feast the virtues of the dead are extolled while everybody celebrates. For the Tlingit, to die is to pass into a fuller life and is something to be happy over. In the past suicide was a common event, thought often to be the release for inherited obligations and burdens.

In the past, Tlingits practiced cremation exclusively. A large quantity of dry wood was piled on a selected place at the beach. The corpse was placed on the wood, and green branches put over the body. With a ceremony of chanting and mourning a fire was lit to the dry wood and the body was burned in the sight of all the people. Many times the bereaved wife, or father, or mother, would be so overcome with emotion, that they would try to throw themselves into the fire. The missionaries rebelled against this and the cremation practice was stopped. Today burial or a less exuberant cremation ceremony is utilized.

Memorial pole, Wrangell—probably depicting some important event about the deceased's abilities as a great fisherman.

Right: *Fine Bear Crest on mortuary pole.*

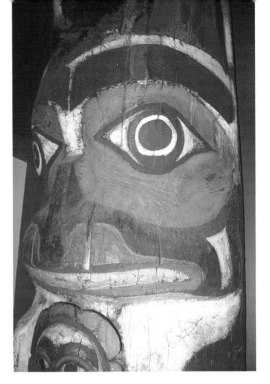

Below: *Klawock Village Totem Park with old poles overlooking the cannery. In the early days it was a natural event for many of the poles to be left to fall down and rot. Today of course we attempt to preserve the old poles for tourists and white man's 'cultural' reasons.*
Photo: Marilyn Williams

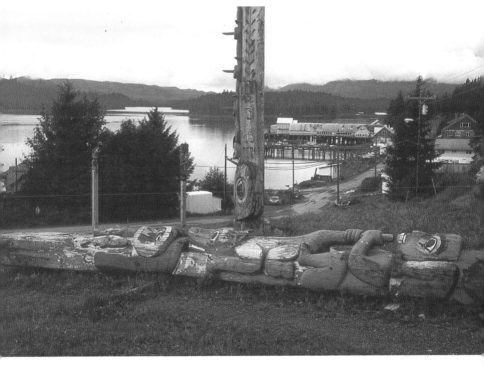

Above: Tlingit burial grave markers from the early 1900s. These replaced the earlier custom of cremation which was opposed by the clergy when they saw distraught relatives flinging themselves onto the fires.

Opposite: *Finely carved grave marker in Ketchikan.*

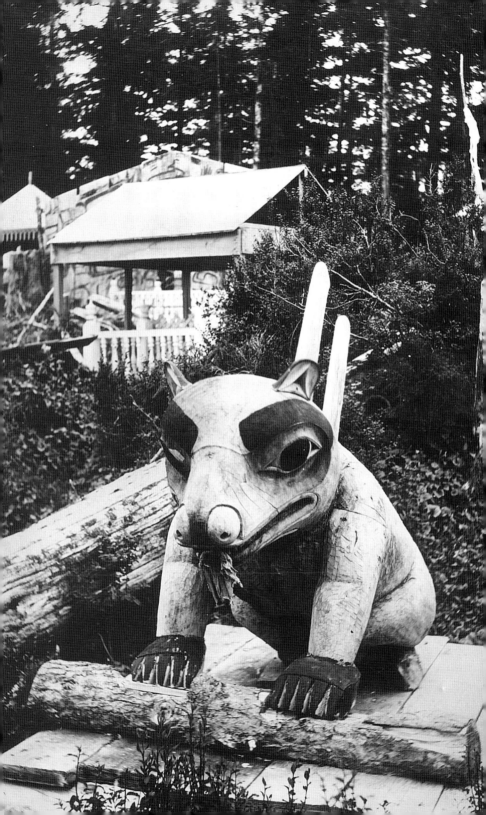

Carvings

Canoes

The Tlingit were expert stone carvers, copper workers, wood workers, weavers, and basket makers. Today, after several decades of reduced artistic production, the arts and crafts are seeing considerable resurgence. The men made dugout canoes from red cedar. The large seagoing war canoes were up to fifty feet long and able to carry forty or fifty men. The prow of the war canoe was usually adorned with tribal crests. These canoes were paddled all the way from Alaska to Puget Sound and even down the outside coast to California on raids to capture slaves and take bounty. These larger canoes were sometimes sailed using square rigged sails. Smaller eight to twenty foot canoes were used for utilitarian purposes such as hunting and fishing in the inshore waters and rivers.

While many village men were involved in the total building of a canoe, the job was supervised by the master carver—a renowned individual—sometimes even a village chief. This head carver or another master carver and his assistants also carved the totems and inside house posts. The dugout canoe construction was quite time consuming to avoid cracks and splitting. This involved heating and steaming the logs so they could be widened as the inside wood was removed by fire and adzing.

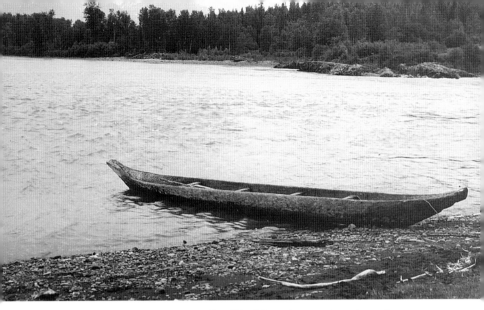

Small inside waters or river dugout canoe.

Right: *Gament, a spiritual guide in bow of Chilkat canoe pulled up at potlatch in Klukwan 1890.*

Below: *Tlingit canoes under sail. To ease the long trips south to take booty and slaves from Puget Sound and the California coast the Tlingit rigged square sails on their ocean going canoes.*
Photos this page: Canadian Museum of Civilization

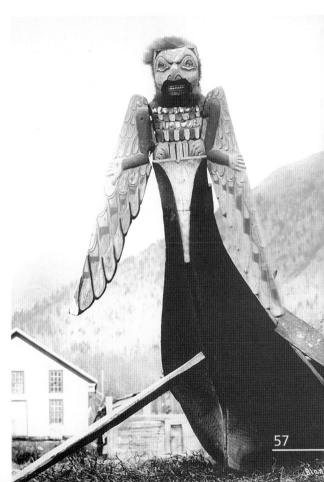

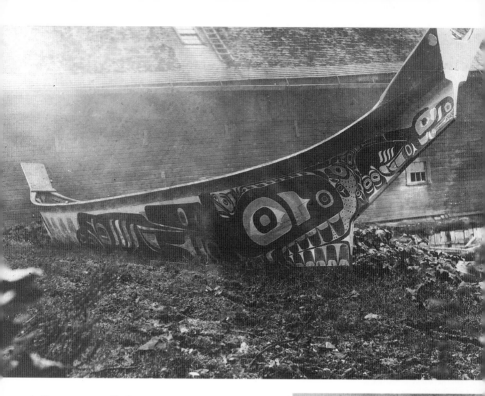

A fine canoe pulled up at Sitka circa 1894.
Photo: Canadian Museum of Civilization

Opposite, top: *Another elegant but aging canoe in front of the Chilkat lodge in Haines.*

Right: *Large northern war canoe under construction being steamed by placing hot rocks into water inside the hull to make supple for spreading.*
Photo: Canadian Museum of Civilization

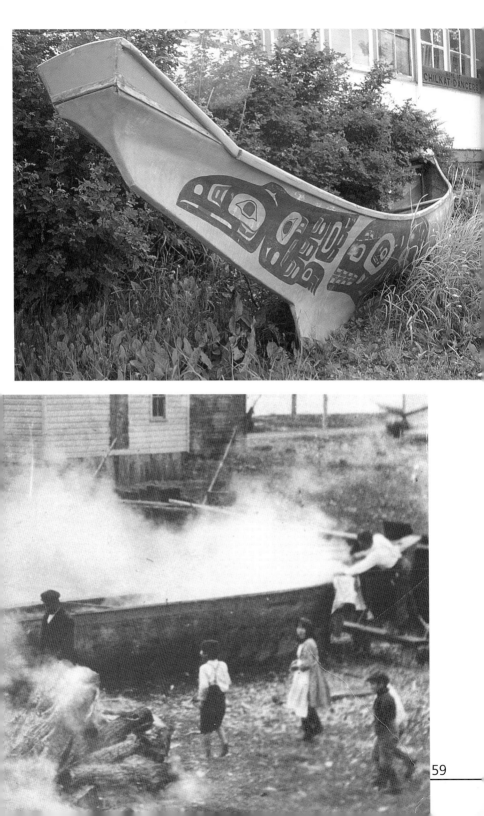

A famous Curtis photograph of a northern style canoe heading for a potlatch with the passengers dressed in their ceremonial finery.

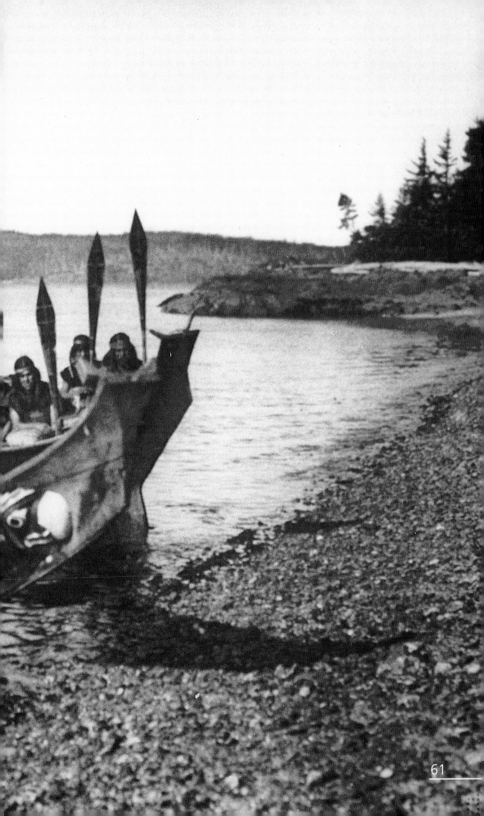

... and Totems

Totem poles standing twenty or more feet high were of great significance to the Tlingit tribes, for in the absence of a written language they represented a major tool for recording and transmitting history and events from day to day and generation to generation.

The poles were made up of distinct emblem or crest elements. Some crests represented real animals such as killer whales, eagles, or sea otters. Others represented specific supernatural or mythological versions of Killer Whale, Thunderbird, Frog (the keeper of the earth's treasures) or Raven (the trickster and creator of all things).

A totem is read from the bottom up, but it contains only a list of crests, not a story. The meaning of the specific crests and why they exist in a particular order in the story was originally told at the potlatch or ceremony when the pole was raised. Two poles containing the same crests would represent different stories. It was during the fireside evening talks that these stories would be repeated.

There were three types of totem poles: a debt totem, a mortuary totem, and a monument or commemorative totem. The least expensive was the pole carved to show that one tribe or person owed another a debt. When the debt was paid, the pole was destroyed. The mortuary or burial pole contained the cremated remains of the deceased stored at the top. The most elaborate pole was the monument or potlatch pole raised to commemorate a special occasion such as a wedding, a great battle, the acquisition of a new guardian spirit, song, crest or a person's entry into man or womanhood or into a secret society.

When the Indians abandoned their old villages to live in towns or go "below" to the United States, many of the large outside totems, exposed to the elements, deteriorated. In the 1940s under the supervision of the Forest Service, the totem poles were restored or duplicated for exhibit at Saxman, New Kasaan, Wrangell, Sitka, and on the school ground of Klawock, Alaska. The totems of Klawock were brought from the deserted village of Tuxekan. Today Tlingit children are once again learning about their history and customs from the poles.

Some of the early missionaries thought the totem poles were idols and religious symbols and did not encourage the carvers, but today groups of natives carve with modern tools and color the new totems with natural vegetable and mineral paints, according to age-old techniques. This traditional artistic resurgence is bringing both pride and many dollars into the culture.

Opposite: *Tlingit inside house post, Juneau Museum.*

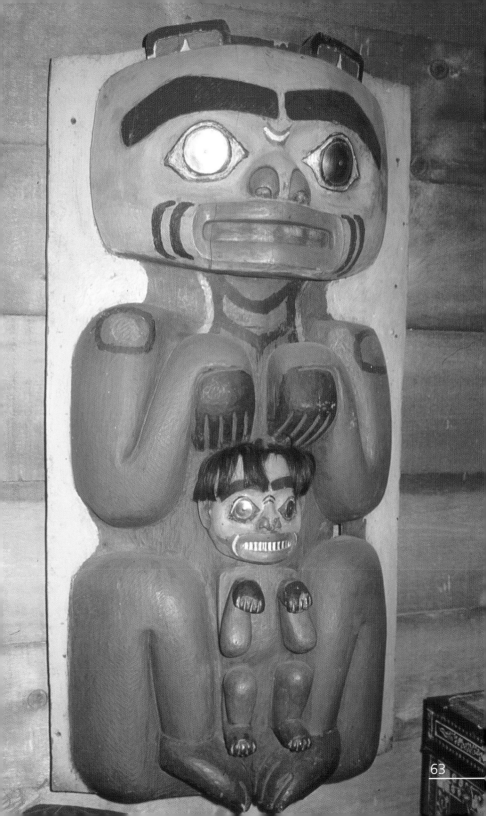

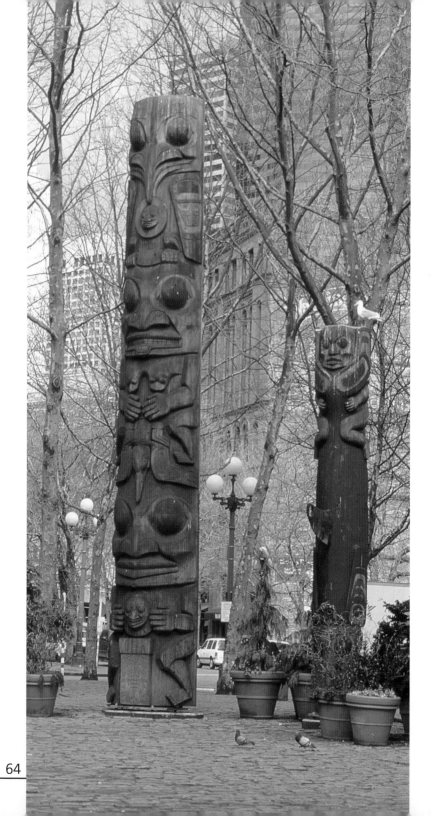

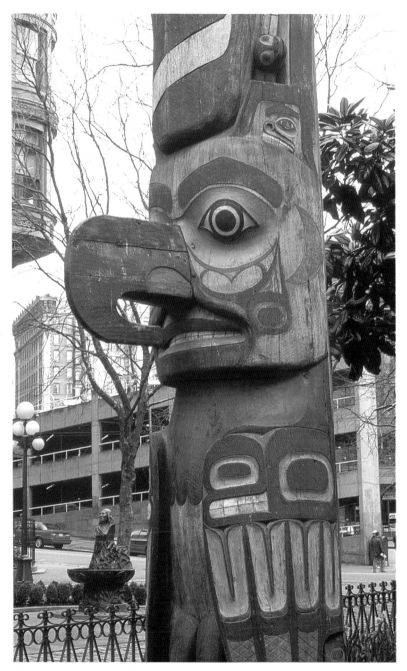

Above and opposite: *Tlingit poles in Pioneer Square in Seattle, Washington. This fine collection has been replicated from poles standing in Alaska.*

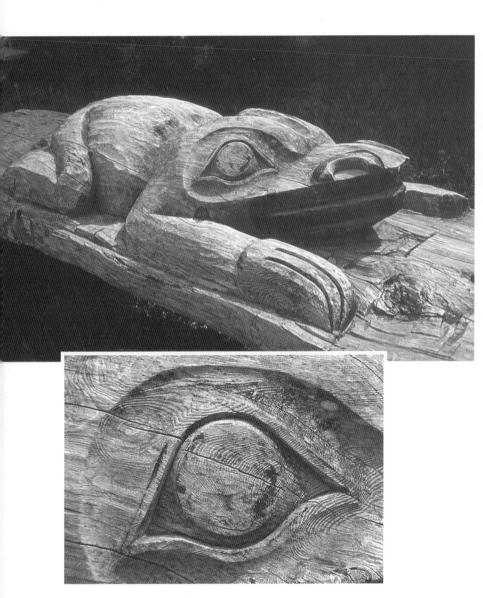

Above and detail inset: *Frog crest.*

Opposite: *Two fine poles outside Chief Shakes' house at Fort Wrangell, 1901. The one is a Bear Crest and the other a double Killer Whale.*
Photo: Canadian Museum of Civilization

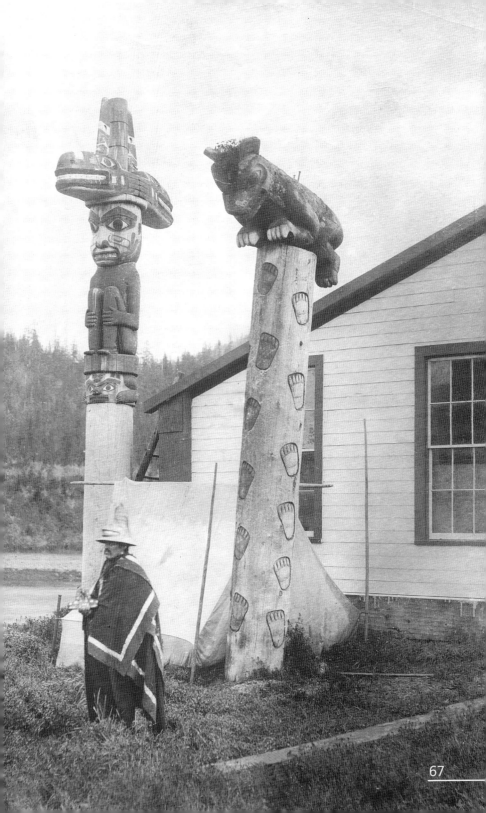

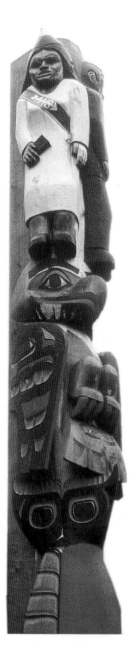

Left and below: *Contemporary pole at Ketchikan: white man, eagle, killer whale, man crest.*

Right: *Single figure Man Pole, Wrangell.*

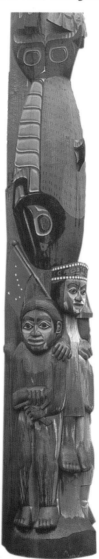

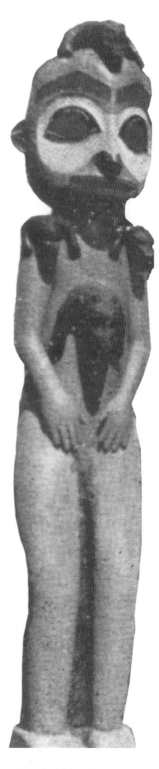

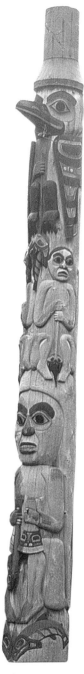

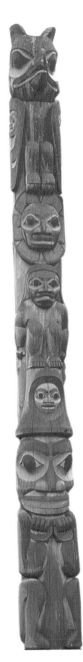

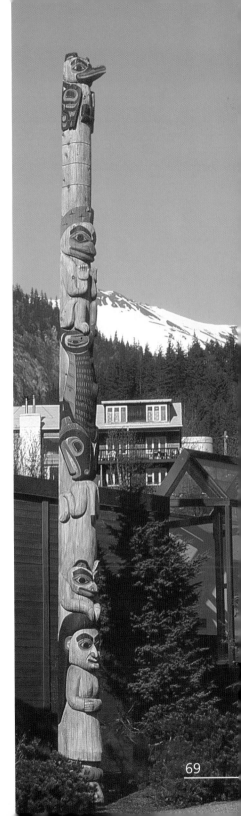

Above: *Two poles at the Totem Heritage Center, Ketchikan.*

Right: *Contemporary raven pole in the traditional style on the grounds of the Juneau Museum.*

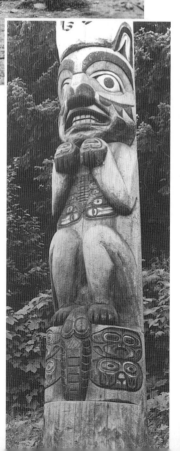

Above: *Poles outside the Chief's house at Wrangell 1907.*
Photo: Canadian Museum of Civilization

Right: *Tlingit pole showing Beaver and Bear Crests at Auk Village near Juneau circa 1900.*
Photo: Canadian Museum of Civilization

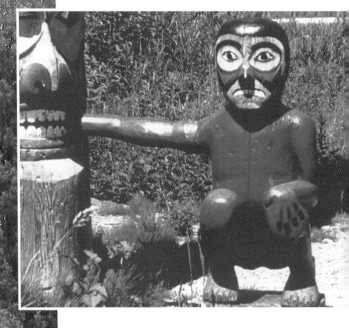

Above and left: *The Memorial Pole Giant Rock Oyster. This pole was restored during the 1930s. The carver is unknown. Saxman Totem Park, Saxman, Alaska.* Photo: Marilyn Williams and Wolfgang Jilek.

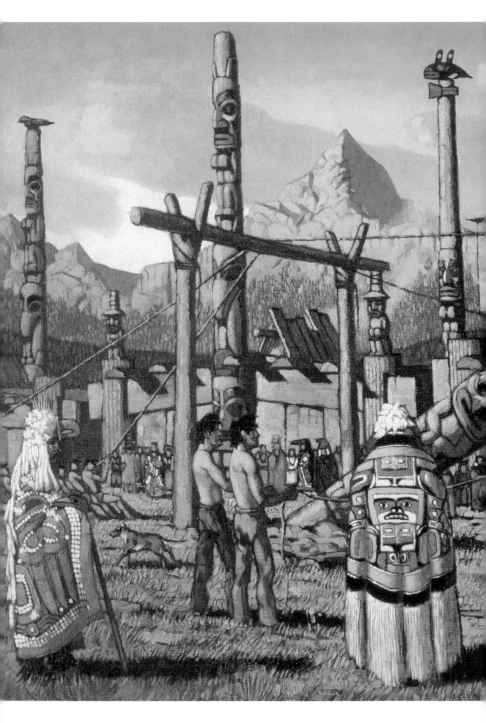

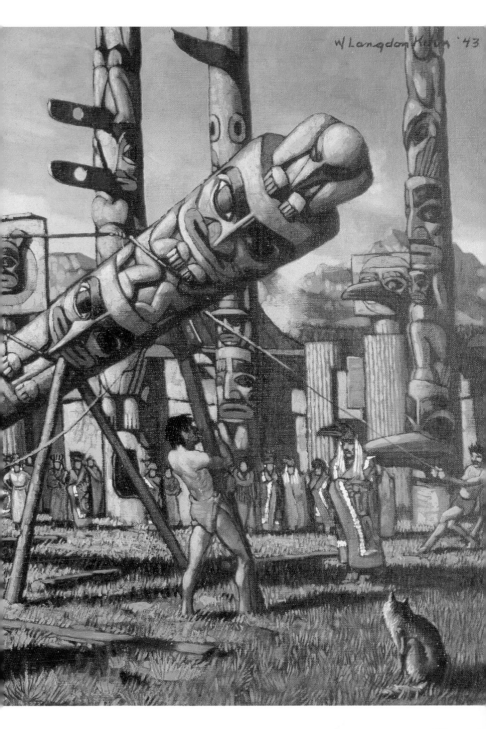

Tlingit potlatch pole raising ceremony. Painting: W. Langdon Kihn. NGS

73

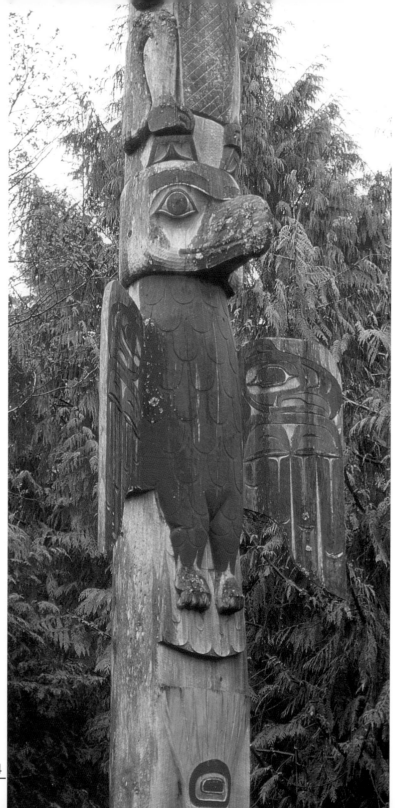

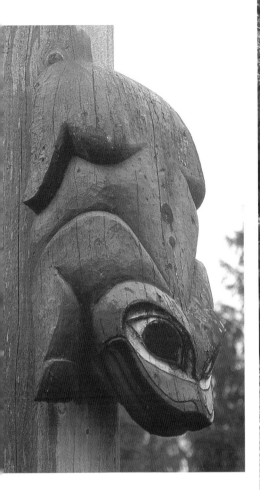

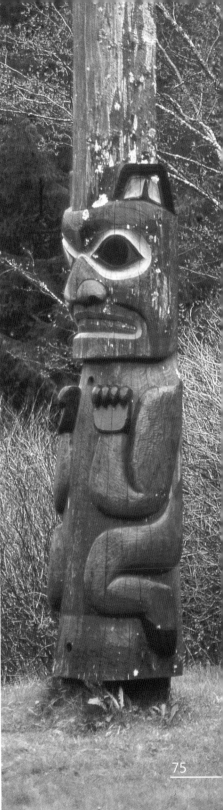

Above and right: *Saxman Village pole crest figures: Frog on left, Man figure on right.*

Opposite: *Raven crest on another old pole—aging gracefully at Saxman Village, Ketchikan.*

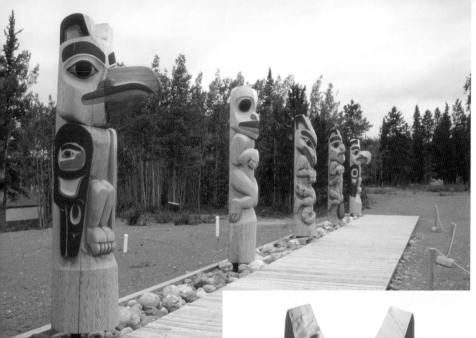

Poles at Teslin Lake.
Above: *Raven figure in foreground.*

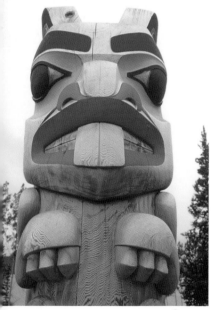

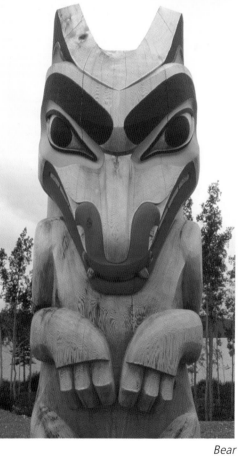

Beaver

Bear

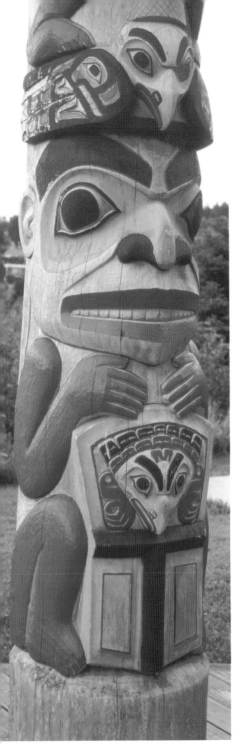

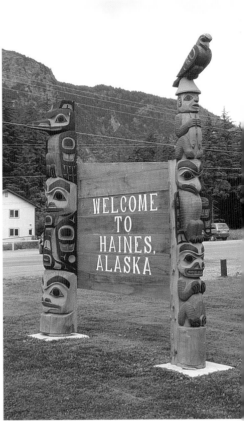

Haines not only has air and cruise ship access, but has driving access through some of the most spectacular British Columbia alpine country down the famous Chilkat River Valley—famous for its huge bald eagle concentrations.

Masks and implements

Masks and crest figures were each owned by individuals and the rights to these were passed on by marriage, inheritance or when captured or lost in war. The crest figures represented both the real and supernatural creatures and each individual could modify these masks to suit the story being told. Some masks had moveable parts enabling the wearer to 'transform' from one being into another and back again to facilitate the story. Today these transformation masks are the most sought after by collectors.

Boxes for storing food and ceremonial dress and masks were either plain or elaborately carved and painted and these were stored in the longhouses. The four sides of such a box were made out of one uncut cedar board so as to produce only one seam. They steamed these boards to bend them and the joint was sewn. Steam was produced by dropping hot rocks into water.

Alder was commonly used for rattles, fishing hooks and floats, and woodworking tool handles. Practically every tool or item of use was intricately carved. Hunting knives and spear points were carefully chipped and ground from rocks or shells and often hafted with cedar bark rope onto handles and shafts. Special labrets or lip plugs were carved from wood, bone or shell and as a sign of beauty in women, were inserted through a cut in the lower lip.

Wooden food and feast bowls and grease dishes were handsomely carved in the form of a beaver or seal. Ladles and spoons were of mountain goat horn or wood. These were both the utilitarian household tools and the gifts of potlatching.

Decorated paddle.

Many of the modern carvers still use the traditional tools such as the 'D' and 'L' adze but with steel blades. They also speed up the process with power saws and jeweler's instruments.

A *Wayne Price starting a pole.*
B *Nathan Jackson working a large feast bowl.*
C *Chief's wooden hat with two woven top notches signifying he held two potlatches.*
D *Lee Wallace working an inside house post.*

Photos this page: Marilyn Williams

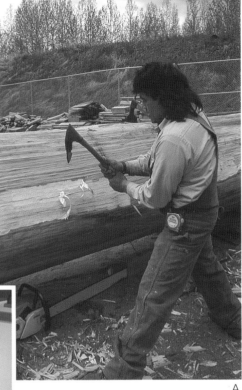

A

B

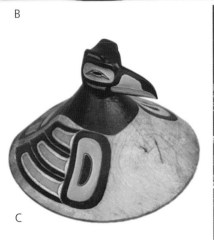

C

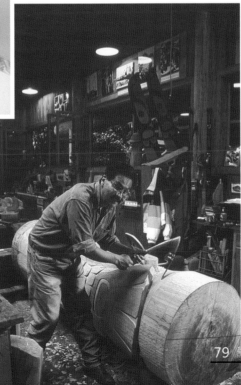

D

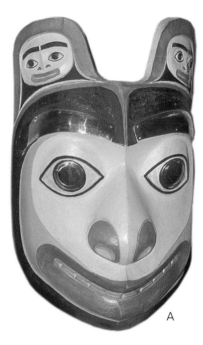

Masks were one of the most important ceremonial objects as they represented both the natural and supernatural characters used to relate stories of brave deeds, supernatural encounters, or community history. A natural creature could usually be differentiated from its unnatural transformed relative by some exaggerated elements. The natural eagle had a normal swept back unencumbered head, the Supernatural Eagle or Thunderbird had horns usually going up, and the highest supernatural being, Komis, was signified by having curls on or within his horns.

A

A Bear mask carved in birch by Greg Horner, Skagway Village Store.
B Man figure mask, Juneau Museum.
C Moon mask by carver Greg Horner, Haines Museum.

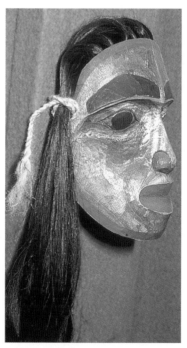

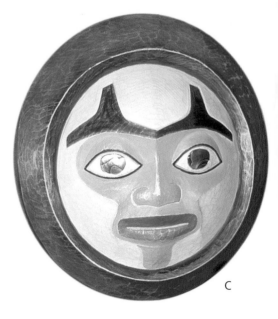

C

B

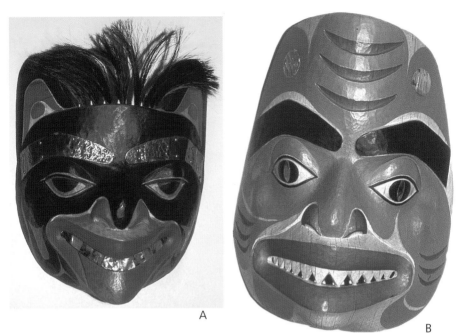

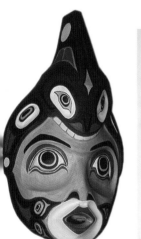

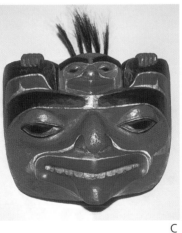

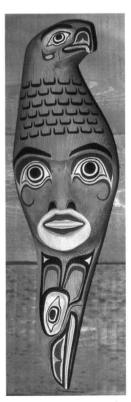

A *Bear mask by carver Ray Watkins, Skagway Museum.*
B *Shark mask by carver Ray Watkins, Skagway Museum.*
C *Bear mask by carver Ray Watkins, Skagway Museum.*
D *Orca Chief by carver Tresham Gregg, Haines.*
E *Very contemporary Eagle-Man plaque.*

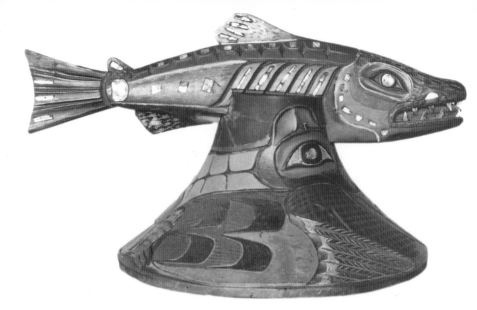

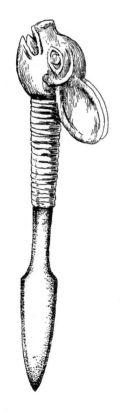

Above: *Carved ceremonial Tlingit Chief's hat topped with salmon.*

Left: *Stone dagger possibly used in war or ceremonial slave killing.*

Below: *Chief's dancing headdress frontal plate elaborately inlaid with abalone shell.*

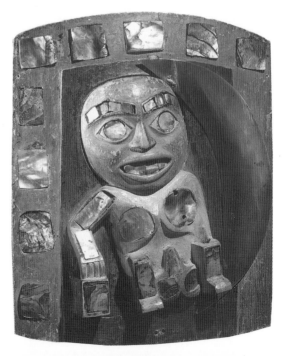

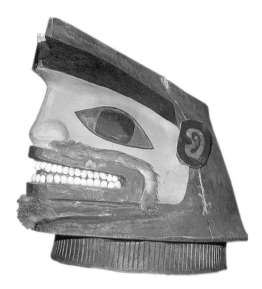

Right: *Tlingit war mask.*

Below: *Haines Heritage Museum Eagle pole gets paint touch-up by Tlingit artist while tourist looks on.*

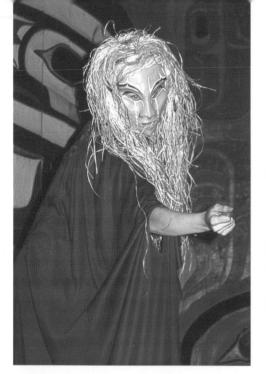

Left: *Dance mask and costume worn at the Haines Tlingit longhouse performances. Carver: Tresham Gregg, Haines.*

Below, left: *Interpretation of cormorant by contemporary Tlingit artist of Seattle.*

Below, right: *Shaman mask. Carver: Tresham Gregg, Haines.*

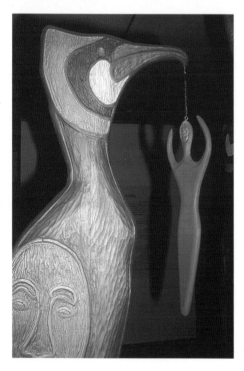

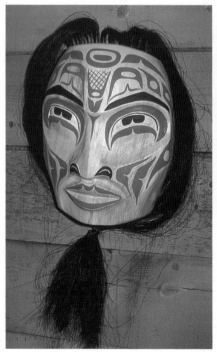

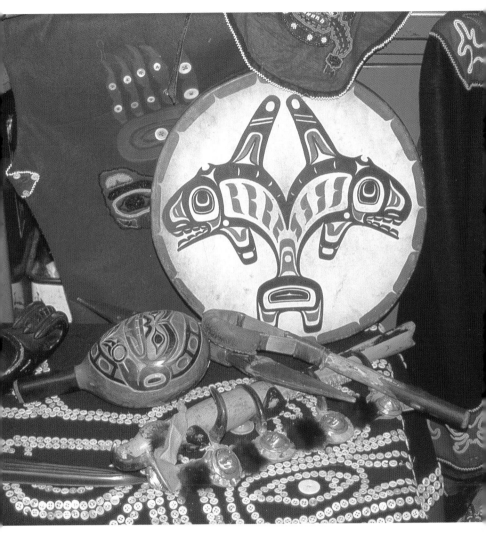

*Collection of Tlingit ceremonial items from potlatch,
Haines Heritage Museum.*

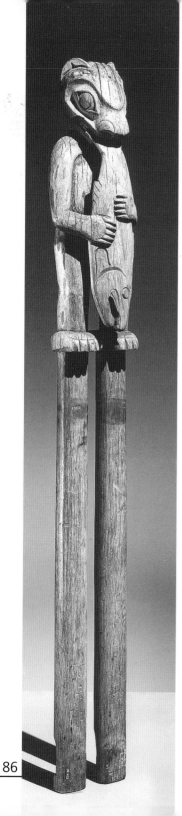

Left: *Old Salmon fishing charm. Carved late 19th century.*
Photo: Field Museum of Natural History

Below: *Top of Shaman's wooden wand, Chilkat family.*
Photo: Field Museum of Natural History

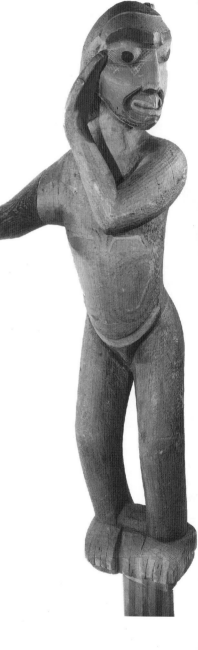

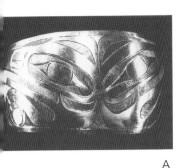

A

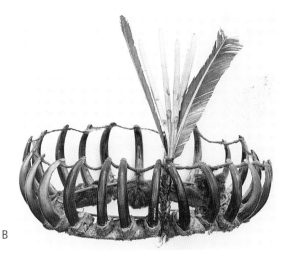

B

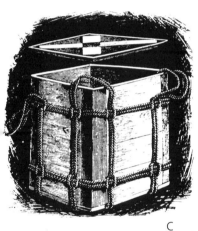

C

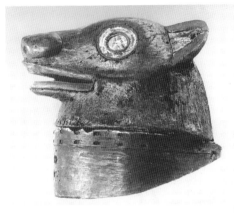

D

A *Silver bracelet from Wrangell.*

B *Grizzly bear claw chiefs crown.*

C *Wooden traveling bent box.*

D *Defensive bear head war mask,
late 1800s.*
Photo: Canadian Museum of Civilization

E *Sea otter harpoons.*

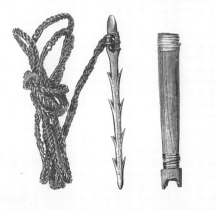

E

Fabrics

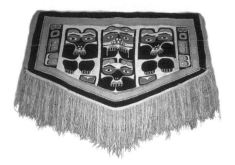

Clothing

The Tlingit originally wore little or no clothing. In cold weather they used blankets made of goats wool. They were largely obtained from the Chilkat tribe, known especially for its excellence in blanket weaving. The Hudson Bay Company found a fertile field for the sale of blankets among the northern tribes, with whom they traded for furs. For special occasions, women had wrap-around skirts carefully twined of cedar bark, with a cape to match, sometimes edged in fur from the sea otter. The use of moccasins, not common to the southern coastal tribes, was borrowed from interior tribes, and were made from seal and deer skin which the native women tanned on frames constructed for that purpose. Deer sinews were used as thread.

Intricately woven Chilkat blankets were worn on festive occasions as were the great bulky and warm sea otter capes. These prized Chilkat blankets were a major trade item, gift of marriage or conquest of war down the entire coast. Even today at a Kwakiutl native potlatch in the more southern areas, the most prestigious item of a chief may be a Chilkat blanket he inherited by birth or marriage.

Animal pelts and woven blankets and grass mats were used on the beds for comfort and warmth and for partitioning the large longhouses into family units for privacy.

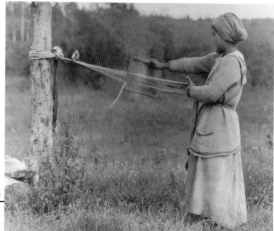

Above: *Chilkat dance blanket, Haines Heritage Museum.*

Left: *Weaving belt of mountain goat wool with hand loom.*
Photo: Canadian Museum of Civilization

Opposite: Display of ceremonial costume, Haines Heritage Museum.

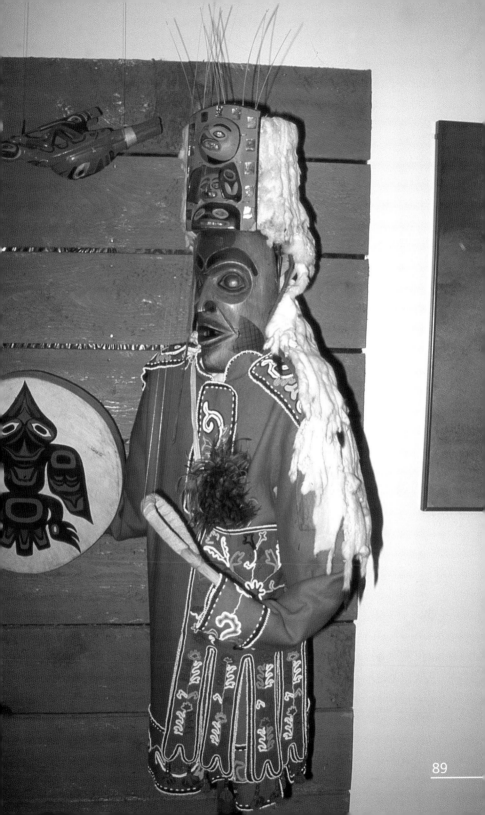

. . . and Weaving

Beaded dall sheep apron, Haines Heritage Museum.

Coarse mats woven from strips of cedar bark served many purposes. The juices of berries, and some minerals and urine were used for coloring.

The Chilkat tribes were famous for their intricate and valued woven dance blankets. These prized Chilkat blankets were traded to the nobility of all Northwest Coast tribes. The patterns were designed by men who were the only ones allowed to know the stories behind the superstitious and mythological crests. The women were then allowed to weave the patterns on their single bar warp-weighted looms, using two and three strand twining. The stronger warp was cedar bark covered with goat wool while the weft, which covered both sides of the warp, was only goat wool; either natural white or dyed black, bluish-green or yellow. The abstracted design represented real or mythological figures used in family crests. It often took a woman an entire year to weave a single blanket which utilized all the wool from three goats.

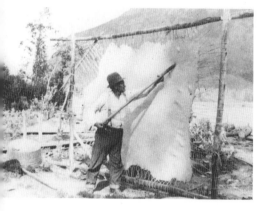

Above: *Billy Williams scraping moose hide.* Photo: Williams family

Right: *Intricately patterned Tlingit dance apron.*

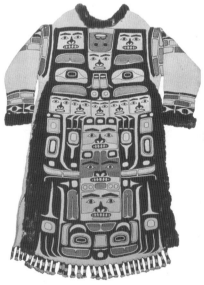

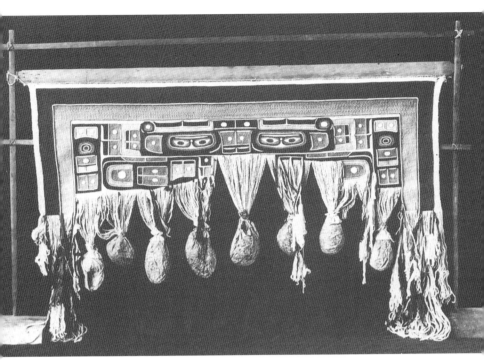

Dance blanket partially woven.

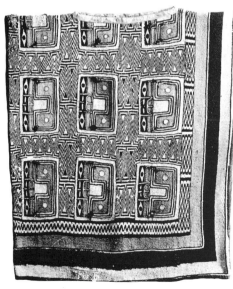

Chilkat goat wool blanket.

Weaving Patterns

Diagonal weave.

Twilled weave.

Twined weave.

Wrapped weave.

Diagonal openwork.

Plain openwork.

. . . and Basketry

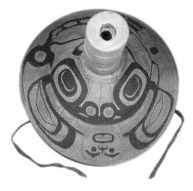

Spruce root twined Chief's hat.

Baskets provided carrying and cooking utensils. Locally available grasses and roots were collected for basket making. Coarsely woven, open twined baskets that allowed for dripping were used for carrying clams and roots. Other were woven so tightly that they held water for cooking. Hot stones were dropped into these to boil the water and cook the contents. Because pottery was entirely unknown to the Northwest tribes, basketry containers were utilized for most food cooking and storage. Hats were woven from spruce roots with basketry rings on the crown, denoting the number of potlatches given by the owner. Additional rings were added as more potlatches were given. The Tlingit made a unique small storage basket in which the lid was a separate compartment that contained puffin beaks which rattled when shaken. The prized rattle tops are still major trade items for tourists today.

Whether making their clothing, housing or ceremonial objects, the Tlingit were masters of effectively utilizing the wildlife and plant resources that abound in the luxuriant northwest.

Wooden Chief's hat showing four woven rings indicating he has given four potlatches, Haines Heritage Museum.

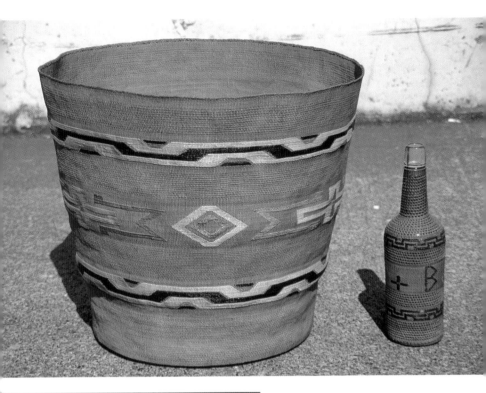

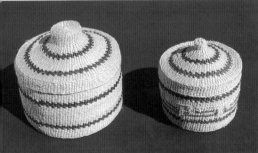

Above: *Exquisitely twined spruce root basket with geometric designs. The covered bottle was a turn of the century adaption to selling items to the tourist trade.*

Left: *Spruce root twined rattle-top baskets. The tops contained puffin beaks that rattled when shaken.*

Right: *More fine twined baskets. The black material in the design was maidenhair fern stems, the brown pattern was from cherry bark. The yellow materials were originally urine stained roots.*

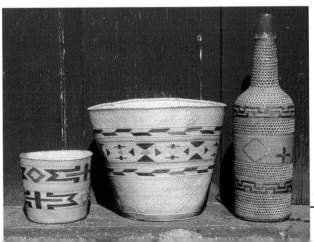

93

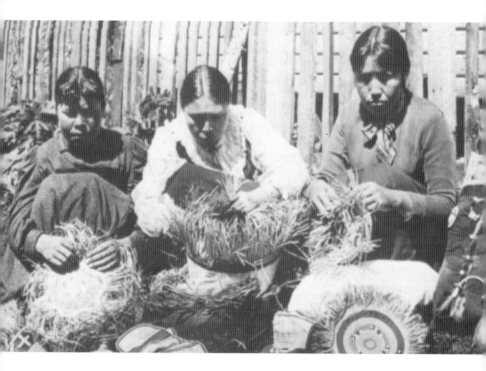

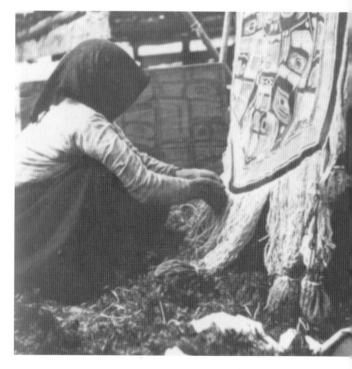

Above: *Tlingit spruce root weavers at Sitka.*
Photo: Canadian Museum of Civilization

Right: *Sitka blanket weaver.*
Photo: Canadian Museum of Civilization

Recommended Reading from
HANCOCK HOUSE PUBLISHERS

NORTHWEST WILDFLOWER SERIES

Coastal Wildflowers
ISBN 0-88839-518-3
5½ x 8½, sc, 96 pages

Mountain Wildflowers
ISBN 0-88839-516-7
5½ x 8½, sc, 96 pages

Dryland Wildflowers
ISBN 0-88839-517-5
5½ x 8½, sc, 96 pages

The Bald Eagle
David Hancock
ISBN 0-88839-536-1
5½ x 8½, sc, 96 pages

Haida
Leslie Drew
ISBN 0-88839-132-3
5½ x 8½, sc, 112 pages

Art of the Totem
Marius Barbeau
ISBN 0-88839-168-4
5½ x 8½, sc, 64 pages

HANCOCK HOUSE PUBLISHERS
Tel: (604) 538-1114 • Fax (604) 538-2262
Web Site: www.hancockhouse.com • *email:* sales@hancockhouse.com